Lacan Reframed

Contemporary Thinkers Reframed Series

Deleuze Reframed ISBN: 978 1 84511 547 0
Damian Sutton & David Martin-Jones

Derrida Reframed ISBN: 978 1 84511 546 3
K. Malcolm Richards

Lacan Reframed ISBN: 978 1 84511 548 7
Steven Z. Levine

Baudrillard Reframed ISBN: 978 1 84511 678 1
Kim Toffoletti

Heidegger Reframed ISBN: 978 1 84511 679 8
Barbara Bolt

Kristeva Reframed ISBN: 978 1 84511 660 6
Estelle Barrett

Lyotard Reframed ISBN: 978 1 84511 680 4
Graham Ralph-Jones

Lacan
Reframed

A Guide for the Arts Student

Steven Z. Levine

I.B. TAURIS

Reprinted in 2011 by I.B.Tauris & Co. Ltd
6 Salem Road, London W2 4BU
175 Fifth Avenue, New York NY 10010
www.ibtauris.com

In the United States and Canada distributed by Palgrave
Macmillan, a division of St. Martin's Press, 175 Fifth Avenue,
New York NY 10010

First published in 2008 by I.B.Tauris & Co. Ltd

ISBN: 978 1 84511 548 7

A full CIP record for this book is available from the British
Library
A full CIP record for this book is available from the Library of
Congress
Library of Congress catalog card: available

Typeset in Egyptienne F by Dexter Haven Associates Ltd, London
Page design by Chris Bromley
Printed and bound in the UK by CPI Antony Rowe, Chippenham.

MIX
Paper from
responsible sources
FSC® C013604

Contents

Acknowledgements

I am grateful to Susan Lawson for inviting me to write this book and for improving it with her keen editorial eye. I also want to thank my students and colleagues in the department of History of Art and the Center for Visual Culture at Bryn Mawr College for tolerating my translation of their scholarship and conversation into the Lacanian terms of the Imaginary, the Symbolic and the Real. Notable among them are David Cast, Christiane Hertel, Homay King, K. Malcolm Richards, Lisa Saltzman and Isabelle Wallace, as well as recent undergraduate and graduate seminar students on self-portraiture and psychoanalysis. The art historians Benjamin Binstock, Bradford Collins, Keith Moxey and Jack Spector gave me the opportunity to present or publish some of my thoughts on art and Lacan, as did the psychoanalysts Heather Craige and David Scharff, and members of the Philadelphia Psychoanalytic Center. Patricia Gherovici and Jean-Michel Rabaté introduced me to Philadelphia's vibrant Lacanian community. And in the background of many of my sentences lies the phenomenology of Michael Fried.

My wife Susan Levine, practitioner of psychoanalysis, and my daughter Madeleine Levine, researcher in social psychology, were indispensable in the completion of this project. My parents Natalie and Reevan Levine opened the space of possibility, and it is in their name and with love that I dedicate this book.

List of illustrations

Modern Art/Licensed by Scala/Art Resource, NY. © 2007 Salvador Dalí, Gala-Salvador Dalí Foundation/Artists Rights Society, NY. 77

Foreword: Why Lacan?

Why Lacan, specifically, for readers such as ourselves, who are students and teachers, producers and consumers in today's complex world of visual culture? The French have a word for it: *un visuel*, a visual person, someone whose way of being in the world is primarily oriented by vision, images, art. Jacques Lacan (1901–81) was such a one, and also not such a one; a passionate man of the visual, to be sure, but still more of the invisible. Friend of modernist artists such as Salvador Dalí, Marcel Duchamp, André Masson, his brother-in law, and Pablo Picasso, his sometime medical patient, Lacan was an occasional collaborator with artists, a long-time collector of art, and an episodic commentator on architecture, sculpture, painting and film, from the palaeolithic caves to the medieval cathedrals and from renaissance to contemporary art. His voluminous contributions to the clinical psychoanalytic literature extended across half a century from the early 1930s to 1981, when he died, and along his tortuous but strangely consistent itinerary in psychoanalytic theory and practice he regularly returned to explanatory analogies borrowed from the visual arts. In this he was not unlike the inventor of psychoanalysis, Sigmund Freud (1856–1939), who famously wrote about the art of Leonardo da Vinci and Michelangelo Buonarroti in the first two decades of the twentieth century and to whose founding psychoanalytic texts Lacan never ceased to return. Others could be Lacanian if they wished, but he always affirmed his allegiance to Freud.

Ecrits, meaning 'Writings', is a lengthy volume collecting many of Lacan's formally presented lectures and essays over the course of thirty years. Published in French to acclaim and notoriety in

1966, when the sixty-five-year-old Lacan was near the height of his fame, *Ecrits* was selectively translated into English by Alan Sheridan in 1977 and in a more reliable and complete edition in 2005 by Bruce Fink. References to works of art adorn several of the essays in *Ecrits*, but none is developed at length and these densely written essays are not the most accessible introduction to the thought of Lacan. Far more numerous were the references to art in Lacan's weekly lectures conducted in Paris in front of packed audiences of psychologists, philosophers, poets, painters and other curious persons from 1953 to 1980. From 1953 to 1963 Lacan spoke at the psychiatric hospital of Sainte Anne to an audience composed primarily of psychoanalysts and psychoanalysts-in-training from the Psychoanalytic Society of Paris, which he had joined in 1934, and from the breakaway society that he had helped to found in 1953, the French Society of Psychoanalysis. Dismissed as a training analyst of the latter group for the infraction of varying the standard hour-long session of psychoanalytic treatment, Lacan founded his own training institution known as the French School of Psychoanalysis and, later, the Freudian School of Paris, in 1964. Sponsored by the Marxist philosopher Louis Althusser, from 1964 to 1968 Lacan held his seminar at a prestigious Parisian centre of higher learning, the Ecole Normale Supérieure, but he was made unwelcome there after he voiced his support for the striking students and workers during the revolutionary events of May 1968. Thereafter invited to lecture at the Faculty of Law of the University of Paris by the cultural anthropologist Claude Lévi-Strauss, Lacan addressed his ever-growing and increasingly mystified audience until the year before his death.

Among Lacan's frequent auditors were many of the most famous French intellectuals from the 1950s through the 1970s. Among them were the existential phenomenologist of visual perception Maurice Merleau-Ponty, the semiological critic of literature and culture Roland Barthes, the historian of knowledge

and power Michel Foucault, the deconstructionist philosopher of language Jacques Derrida, the feminist critics and advocates Luce Irigaray, Hélène Cixous and Julia Kristeva, and many more. Jacques-Alain Miller, a philosophy student of Althusser and later the son-in-law of Lacan, was entrusted in 1973 with the task of transcribing and editing the annual volumes of the long-running public seminar, *Le Séminaire de Jacques Lacan*, a monumental task that is still unfinished today. To date fourteen volumes out of twenty-six have appeared in French and seven have been translated into English, with additional transcriptions, recordings and translations of unpublished sessions available in unauthorised editions and via the Internet. I spent the year 1970–1 as a graduate student in Paris, and although I began to be exposed to Lacanian theory that year in the cinema magazines I compulsively consumed instead of dutifully working on my dissertation on the art of the impressionist painter Claude Monet, I regret to say that I never attended the public seminar of Lacan, then in its eighteenth year. This little book is by way of making up, impossibly, for that failed encounter with Lacan during the brief French flower of my youth.

Why should students of the visual arts bother to read the notoriously difficult writings of Lacan? The reason that I offer here is that the question of how to live our lives is a fundamental question for us, and it is my belief that Lacan helps us to address this question in productive ways. Other species of living creatures on this planet seem to know by natural instinct how to carry on with their lives in their given ecological niches on the land, in the waters and in the skies. Ants do it, bees do it, cats do it, dogs do it, even elephants do it, but unlike these other earthlings with which we share the biosphere of this planet we humans do not seem to know how to do it, for we no longer live in nature by instinct alone. We variously envision our lives in the changing styles of architecture, painting, film and fashion – and there's the rub.

Across the span of human history and across the expanse of the globe, we have always found ourselves ensconced not simply in

a given natural niche but, rather, in a complex cultural situation for which we have been destined by our parents from before the moment of our birth. Born humans all as the result of the chance intertwining of X and Y chromosomes in the universal process of sexual reproduction, we soon obscure that species-wide universality as we take up the tasks and opportunities of our lives within a specific moment in time and at a specific geographical place. We soon discover that we are not simply part of a single family of humanity but rather of particular groupings of different languages, ethnicities, races, religions, social classes, political affiliations, family traditions and, for the readers of this book, artistic schools. How we become new members of these widely varying cultural groupings has always posed profound questions to each and every one of us. The multifarious world of art poses such questions to us.

It is the claim of this book that the spoken and written words of Lacan offer us useful approaches to the fundamental questions of life and art. For Lacan, as I read him, the key to our questions is to recognise to whom they are addressed and from whom answers are expected. Lacan's lesson is that our questions are always addressed to the other who is supposed by us to know the answers, such as parents, teachers, physicians, priests, friends, lovers, even enemies. In the final analysis, our questions are addressed beyond these particular others to the generalised Other of the cultural order into which we are born, in which we are educated, which we willingly or unwillingly join, and in the various idioms of which we must try to formulate answers to our nagging questions: 'What do you want of me?' 'What kind of a person do you expect me to be?'

For Lacan, these existential questions were clarified by Freud in his pioneering efforts to alleviate the psychological suffering of patients for whose enigmatic corporeal symptoms contemporary medical science could offer neither physiological explanation nor promise of cure. Freud learned from the stories of his patients

that their suffering was real, and it is my belief that their anxious questions remain pertinent to us all today. 'Am I a woman or a man?' is the fundamental question posed by the so-called hysterical subject, who stubbornly resists taking up one of the standard roles of masculine and feminine convention. 'Am I alive or am I dead?' is the question enunciated by the so-called obsessional subject, who rigidly insists on enacting the standard role precisely as prescribed by the social code. For each the vital question involves a fundamental anxiety regarding the enigmatic desire enshrined in the demands of the representatives of authority, such as parents, teachers, bosses, supervisors, officers, editors, critics, ministers, rabbis, imams, shamans, gurus, priests.

Each individual subject wonders what the Other, as represented by his or her painting professor, perhaps, wants of him or her. The hysterical subject responds to this basic worry by resisting what she or he imagines the Other wants her or him to be. The resistance of the hysteric is akin to that of the avant-garde artist who refuses to abide by the standard artistic rules of the day. The obsessional subject – or, in our world of visual culture, the academic artist – responds to the imagined desire of the Other by insisting that the normal order must be maintained at all costs. When encountering the hysterical or obsessional questioner in the course of clinical treatment today, the psychoanalyst seeks eventually to convey that there is neither a need to resist nor need to insist upon the reign of the law, for the simple reason that the Other who is supposed to know the answers to life's fundamental questions does not in fact exist as an all-knowing will that must always prevail over the subject's own desire. Through the lengthy and painful process of calling up and eventually cancelling out this constraining fantasy of the Other's desire, the subject of psychoanalysis in the end discovers that he or she is actually free to try to be what he or she uniquely desires to be. There is in our human corporeality a real limit to this freedom of desire that we must acknowledge, but it is not the

conventional limit of the law. The greatest artists have always known this.

In positioning us not in the iron grip of natural instinct but in the malleable grasp of culture, Lacan distinguished three registers of human experience that I will try to animate and keep in play throughout this brief book. Right now, as your eyes visually scan and mentally decode these black marks that we call letters on this otherwise blank page, we are variously immersed in the three dimensions of experience that Lacan identified as the Real, the Symbolic and the Imaginary. The forms of these letters are graphic images – or signifiers, in the terminology taken by Lacan from the Swiss linguist Ferdinand de Saussure – that mobilise the register of visual recognition that Lacan saw as the Imaginary realm. The meanings of these words and sentences are also images, mental images – or signifieds – that participate in the differential interplay of verbal understanding that Lacan named the Symbolic order. Finally, the unmarked blankness against which the visual shapes of letters and verbal meanings of words stand out in their fragile consistency constitutes a necessary ground, which in itself can neither be fully visualised nor verbalised. This blankness of the page, like that of the body and world prior to the mappings and markings of language, is what Lacan enigmatically indexed as the Real. Lacan's uncanny paradox is that the Real comes into being for us only retrospectively, only after its primordial unmarked fullness has been irretrievably lost among the icons and inscriptions of Imaginary and Symbolic signs. Nevertheless, sometimes, as on 9/11 in New York or 7/7 in London, the inhuman meaninglessness of the Real suddenly and traumatically intrudes to destabilise the Imaginary and Symbolic coordinates of our familiar worlds.

When the three initial letters of Real, Symbolic and Imaginary are pronounced in French the resulting acronym, R. S. I., sounds like the word *hérésie*. The intertwining and unravelling of material form and immaterial meaning in this spoken pun is a typical

Lacanian example of the heresy of asserting that these three orders completely cover the whole truth of human experience. Indeed, in such seriously playful nonsense lies the truth according to Lacan, though not the whole truth, as he frequently insisted. On account of our transformation by the introduction of the signifiers of language from a naturally proliferating animal species into culturally regulated and historically differentiated human groupings we have lost immediate access to any instinctual fullness of being in the world. As sighted beings we are left to face up to that primordial loss of the world beneath the gaze of the compensatory visual images with which our cultures confront us and console us. As speaking beings we are asked to make some provisional sense of ourselves in the verbal meanings of the symbols with which our languages address us and attire us. And as corporeal beings we are left to endure the traumatic blankness that silently and invisibly enframes, and eventually explodes, the precarious cultural configurations in which we struggle to live.

So, why Lacan? In order to try to be free.

Chapter 1

The *Da Vinci Code* according to Freud

Let us begin our Lacanian inquiry in art with the most familiar yet also enigmatic work of art in the world, Leonardo's *Mona Lisa* (1503–7), a perennial riddle recently explored in the best-selling novel and blockbuster film *The Da Vinci Code*. Why is the woman smiling at us? Although I have been an art historian for more than thirty years I really have no idea, but let us see whether Lacan knew something of the secret of her smile. In one of his essays he compared the enigma of the *Mona Lisa* with that of the young patient known as Dora, who abruptly broke off her treatment with Freud when he plied her with too many answers, failing to ask the questions that might have helped her toward her own cure. Identifying himself more with Dora than with Freud, Lacan insisted that the analyst knows nothing, that the analyst, like the hysteric, only asks questions. That is what the enigmatic face of art makes us do. It hystericises us, and in our anxiety we aim to resolve its enigma by historicising it.

The Mona Lisa smile

What was painted in that famous smile, or so Freud imagined in his interpretation of the work, was the lost loving smile of the artist's mother that had formerly looked upon him as a child. Within a decade of Freud's discussion of the *Mona Lisa* the anti-modernist artist Duchamp drew a moustache on the face of a postcard reproduction of the painting and inscribed it with the letters *L. H. O. O. Q.* (1919; Figure 1). Punning in French, just as his

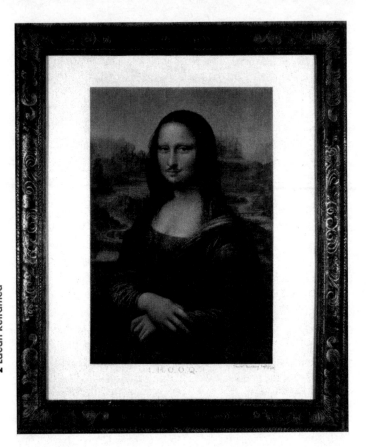

1. Marcel Duchamp, *L.H.O.O.Q.* (1919).

friend Lacan would do later, Duchamp vulgarly tells us that she has a hot ass, *elle a chaud au cul*. Hearing the title pronounced in English, we are imperatively told, 'Look!' Later, in 1965, Duchamp affixed an undefaced reproduction of the *Mona Lisa* to a mat, entitling it *L. H. O. O. Q. rasée*, or the *Mona Lisa shaved*.

In 1954 Lacan's surrealist collaborator posed for a self-portrait photograph as a twirlingly mustachioed hybrid Dalí/Lisa. Four decades later a similar act of cross-gendered self-projection was performed by the Japanese postmodernist photographer Yasumasa Morimura, who presented himself as a naked, pregnant, Asian Mona Lisa in 1998. The Russian painter Kasimir Malevich in 1914, the French painter Fernand Léger in 1930, the American painters Andy Warhol and Jasper Johns in the 1960s, the television Muppet Miss Piggy in the 1980s, the White House intern Monica Lewinsky in the 1990s, and the film actress Julia Roberts in 2003 all variously re-posed in their paintings, photographs and performances the enigma of that smile. A contrarian cartoon in the *New Yorker* magazine wondered why she wasn't laughing, and it is my gambit in this book that reading Lacan will help us clarify why these practitioners of elite and popular culture have continued to sustain an ageless obsession in seeking an answer to a question posed by a 500-year-old painting of a long-deceased Florentine lady's face. Media accounts at the time of this writing suggest on the basis of her costume that she was either pregnant or had just given birth. Is that the truth?

Like many others before and since, Freud travelled to the Louvre Museum in Paris to confront the enigma of the woman's smile. Her smile has been seen by generations of commentators as deeply alluring yet profoundly troubling all at the same time. Later, Freud asked the infamous question 'What does Woman want?', and an answer of sorts is already implied in the title of the little book he published a century ago, *Leonardo da Vinci and a Memory of His Childhood* (1910). There he proposed that, while painting the face of this Florentine lady, Leonardo was reminded of the smile of his mother at the time when he was a child, and it was this smile in all its ambiguous allure that he reanimated in a painting which he then found himself unable to complete. Thus the psychoanalyst sought to solve a riddle that art critics had been unable to solve themselves, that of Leonardo's ambivalent intention and inhibited

execution. Freud's account of the recovery in a work of art of a woman's lost smile – a lost object in the language of psychoanalysis – inaugurated the hundred-year-long altercation between art and psychoanalysis that is my subject here.

The lost object was one of the key principles of psychoanalysis that Freud was elaborating in the fertile decade between the publication of his most famous work, *The Interpretation of Dreams* (1900), and his speculation concerning Leonardo's childhood memory. Like a dream, Freud argued, Leonardo's childhood memory was not the objective transcription of an event in the past but rather a subjective fantasy in which a wish of the artist was visually staged. The wish of the artist was to see once again the lost smile of his mother in his painting of the elegant lady's smile, but just as importantly it was to be seen by this stand-in for his mother as if in a bittersweet moment of his mother's lost loving gaze.

On one side was the smiling face, at once the present object of his gaze and the lost object of his wish. On the other side was the smiled-at face of the wishing and desiring subject, the painter. Linking the mother, the son and the lady was the work of art in the ambiguity of its associations and ambivalence of its affections. This renewed linkage of the desiring subject and the lost object was the vital work performed by the work of art, a psychological action that Freud called sublimation. In chemistry sublimation is the direct passage of a solid substance into a gaseous state. In psychoanalysis, sublimation is the transformation of an intensely private desire into a publicly valued piece of cultural expression. This is a key concept for both Freud and Lacan.

As hypothesised by Freud, Leonardo's private desire was to look and to be looked at with love, an infantile lust to see and to show – voyeurism and exhibitionism – that the psychoanalyst had described in *Three Essays on the Theory of Sexuality* (1905). In Freud's story the young boy's mother was imagined to be the original object of his desire, just as he was said to desire to be the

reciprocal object of her desire. In addition to his desire for her desire he also identified himself with her in his own manner of desiring, as he learned to substitute for her lost childhood embrace the subsequent objects of adult love. The mother's lost loving look was at once the specific object of Leonardo's desire and the general cause of his own desirousness as he scanned the faces of potential partners in love for the kind of loving look he had once seen in her eyes, or remembered he had seen, or dreamed he had seen, or wished he had seen. In life you do not always get what you want, but in the making and viewing of art you may get some satisfaction. And for Mick Jagger and Leonardo that is sublimation.

In identifying Leonardo's looking for love with his mother's loving look, Freud sought to explain the apparent historical fact of the artist's predilection to love – and to paint – beautiful male youths like himself at the time that his mother had loved him. Leonardo was thus said to follow the pathway of the mythological hunter Narcissus, who saw in a forest pool a beautiful face looking at him and fell in love at first sight with that face. Initially the jubilant Narcissus did not realise that the face in the pool was merely the reflection of his own, but in a second moment of alienation he came to recognise that this was so. The result of this impossible love for a reflected image of himself was the splitting of his being between desiring subject and desired object, an unbridgeable split that was spanned only by his dying metamorphosis into the beautiful flower that still bears his name.

What I wish to stress in Freud's psychoanalytic reading of the myth is that the beautiful image of the self encountered by Narcissus/Leonardo was located outside the individual subject in the mirror image of the pool or in the mother's mirroring eye. By means of what Freud called the mode of narcissistic identification, the corporeal look of the eye was placed in a strict but skewed correlation with the psychological birth of the Ego as an alluring yet inaccessible image perceived outside itself. Our own Ego is an alter Ego. Or, as Lacan said in

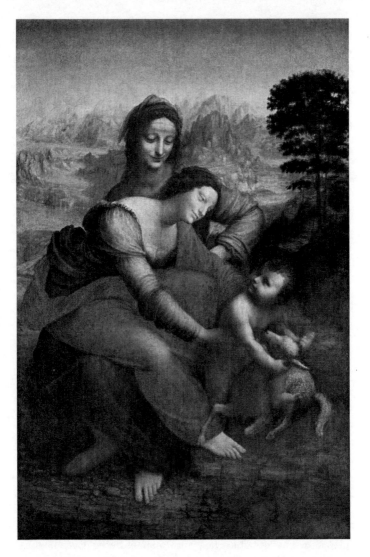

2. Leonardo da Vinci, *The Madonna and Child with Saint Anne* (1508–10).

quoting the French nineteenth-century poet Arthur Rimbaud, 'I is another.'

Freud saw a redoubling of Leonardo's desire in another of the artist's paintings at the Louvre, *The Madonna and Child with Saint Anne* (1508–10; Figure 2). Here the mother's lost smile was repeated in the twin visages of the youthful Madonna, bending to pull to her lap the baby Jesus in whose eyes she looks, and the Madonna's own mother, an uncannily youthful Saint Anne, from whose throne-like lap the Madonna twists down toward her child playing with a lamb upon the ground. Whereas this human trinity of grandmother Anne, mother Mary and baby Jesus came from the Christian story of the Holy Family, the two smiling mothers were also seen to correspond to the personal history of the painter, who was first nourished in the peasant home of his unwed mother before being removed to the urban residence of his father, where he was raised by his father's mother and lawful wife. As in the blurred image of a dream, these two mothers and their unequal circumstances of matrimony, joy and wealth appeared as if condensed into a single two-headed configuration in which the lost maternal look was wishfully refound by the adult painter not once but twice. Leonardo had thus not only recovered the lost loving look of his mothers; he had also reclaimed the lost image of himself as beloved that was reflected in their eyes. In this way, according to Freud's theory of art as a sublimated satisfaction for an unrealised desire, Leonardo was said to triumph indirectly in his art over what he could not directly triumph over in his life. There was at least a partial consolation there.

Almost fifty years after the publication of Freud's treatise Lacan returned to the analyst's interpretation in his lectures of 1957, insisting not on the artist's supposed satisfaction in the refinding of the mother's lost smile but, rather, on the representation in the painting of the Madonna's own wistful look of loss or lack. Unlike the nurturing breast, enlivening voice, or lingering gaze that must be lost to her son if he is to grow beyond

the limits of the nursery, the lost object that Lacan saw in the mother's look of desire is the boy-child himself in the form of the notorious psychoanalytic object of fantasy known as the maternal phallus, the symbol of the desired penis that she is said not to have. This illusory object is a part of the body that the son imagines his mother to have or perhaps not to have; to have and at the same time not to have; to have in the very form of a lack. This imagining of the maternal phallus is the child's answer to the inaugural question of desire: 'What does Mother want?' What does she want both in the sense of what does she lack and in the sense of what might she desire to fill up this empty place? Must she really lose her baby and can she ever find its like again? And can I ever be, and do I really want to be, the Imaginary phallus that she lacks?

The controversial idea of the maternal phallus has fomented great resistance on the part of women authors and analysts over the course of many decades, but it would take more than the little bit of exposition at my disposal to lay out all the stakes of this ongoing debate. Suffice it to say that the crucial point for Lacan is to see in the so-called maternal phallus not the Imaginary outline of a penis that would be physiologically useless to a mother's Real corporeality but, rather, the Symbolic emblem of her lack of the elevated social status traditionally conferred upon fathers, brothers, husbands and sons in patriarchal societies. More simply, the maternal phallus as lacking is the symbol of whatever it is beyond her condition as mother that she might desire, or that her son or daughter might imagine her to desire, in her capacity as friend, lover, or perhaps writer or painter in a room of her own.

The bird's tale

Let us return to the memory of Leonardo's childhood not as ambivalently enshrined in a painted smile but as enigmatically recorded in the written passage that provided the basis for Freud's explanation of the artist's perplexing inhibition to complete his

works. In the midst of a discussion in his notebook on the flight of birds Leonardo interrupted himself to record his only self-described childhood memory. In this memory the adult artist and scientist saw himself as a baby in a crib being visited by a large bird, which inserted its tail in his mouth, beating it about inside. What might this strange tale have possibly meant to the artist, and what might it mean to us?

According to the substitutive mechanisms of fantasy as proposed by Freud, the representation of something of disturbing affective interest was replaced in Leonardo's recorded memory by the representation of something else of less disturbing intensity. Here the striking insertion of the bird's tail in the child's mouth replaced in disguised form the infantile scene of nursing at the nipple that Freud believed was too full of disruptive emotion for direct representation in Leonardo's text. This first level of the scenario's disguise – or displacement, in psychoanalytic parlance – corresponded to the location of the event in early childhood; but Freud saw more here as well. The displaced memory-fantasy of the bird's tail inserted in his mouth as a child also screened from the adult artist the socially unacceptable wish of having a penis inserted in his mouth in an adult sexual act. Thus, in one fell swoop Leonardo's disrupted love for his mother and censored love for beautiful young men was both revealed and concealed in the intrusive oral thrust of a bird's tail. As we will see in many other examples to come, the double function of the fantasy, the dream and the work of art was to reveal the truth and conceal it as well.

Freud was keenly aware that most early twentieth-century readers would have found it distasteful in the extreme to follow him in his apparently mad substitutive leaps along a chain of association between a tail, a penis and a nipple, between a natural human instinct, a taboo homosexual act and a bizarre ornithological scene. In unravelling the tangled knot of Leonardo's personality Freud sought documentary support in an ancient myth that might have been known to the renaissance artist. In this

Egyptian myth Freud found the same motifs of the bird, the breast and the penis united in the erection-bearing body of the vulture-headed mother goddess Mut. This was a potentially significant corroboration for Freud, but it turned out that in pursuing the mythology of the phallic female vulture Freud went astray in relying on an erroneous German translation of Leonardo's original Italian word for his bird of childhood memory. That word, *nibbio*, ought to have been translated as kite, a hawk-like bird of prey unencumbered by the myth of the maternal phallus. Much has been made of Freud's unwilled, or perhaps even willful, error of translation in the voluminous criticism that has delighted in debunking his work, but the psychological point for which Freud was seeking mythological and archaeological confirmation remained intact nonetheless. This was the attribution of the phallus to the mother by her young son on the assumption that this seemingly all-powerful nourisher of life must not be thought to lack the same useful and pleasurable organ that he himself enjoyed lest by some fateful mischance he might come to lack it too.

The fetish of Little Hans

Basing his assertions on the clinical case of a five-year-old boy known as Little Hans that he had published just a year before his Leonardo tale, Freud claimed that the boy's attribution to his mother of a phallus might persist even in the face of contradictory observations of the real or represented body of a woman or girl. According to the notorious Freudian scenario of penis envy, the young boy's sister might blame her mother for failing to provide her with the phallus that her brother enjoyed. As for Little Hans, it was his stubborn belief that his mother had to have a penis even though it was hidden from view; his sister's penis couldn't be seen because it was still little and would grow later; or perhaps their penises had become detached, by accident or in punishment, and if so perhaps his could become detached as well. In order to overcome such castration anxiety, as it was called, Little Hans fashioned for

himself the neurotic symptom of a fear of horses in the street, in which his intolerable fear of castration was effectively displaced.

In his commentary on the case of Little Hans, Lacan stressed that the horse of the boy's phobia may have functioned as a fetish in which the fantasy of the maternal phallus was both affirmed and denied. Lacan insisted that it was this Symbolic negation of Imaginary visual experience – the observable presence or absence of the genitals of the mother or the horse – that constituted the fundamental discovery of Freud. Do not trust what you see with your eyesight but what you say with your insight according to the gaze of your desire. This split between the Imaginary eye and the Symbolic gaze is one of the key ideas of Lacan for those of us who are students and practitioners of the visual arts. Please stay tuned.

The unconscious

Lacan always insisted that he was nothing but a Freudian and that his teaching was nothing but a return to Freud by way of a close rereading of his fundamental texts. First and foremost for Lacan was *The Interpretation of Dreams*, where Freud articulated the grammatical mechanisms through which were linked the words and pictures of the dream and the unsaid and unseen desire of the dreamer. Just as important for Lacan were Freud's discussions of our bungled actions and slips of the tongue – the famous Freudian slips – in *The Psychopathology of Everyday Life* (1901), and his treatment of the compact formulation and explosive release of unspoken or socially censored desire in *Jokes and Their Relation to the Unconscious* (1905). It was in the name of the transformative wordplay of dreams, slips and puns that Lacan's most famous dictum was spoken again and again in his work: 'The unconscious is structured like a language.'

The unconscious. There, I've finally said it! But just what is the unconscious? Or, better, what is it not? The Freudian unconscious as understood by Lacan was not some primal repertory of bestial instincts that inexorably motivated human beings to perpetrate

horrendous deeds of murder, maiming, mayhem and lust. For Lacan, the Freudian unconscious was not some darkly hidden reservoir of animal instincts imperfectly suppressed by civilisation but, rather, an inescapable domain of language literally lying in plain view, for instance in the full black letters and empty white blanks of the very lines of type you are reading now.

As these words are written and as they are read in turn, a subject – the subject of the unconscious – intermittently flickers into being and just as quickly fades from view, retaining the trace of the word just read, hanging on the anticipated word to come, and retroactively conferring meaning at the end of this unwinding chain of words. The instability of this position of the subject in language is a function of our deciphering of these letters and blanks all the way to the end of this book and beyond. Such reading is an unending process of subjecting ourselves to these graphic images of words according to our grasp of the current idioms of the English language. We would not be the paradoxical psychological subjects we are but merely the physiological organisms and physical objects we are as well without this matter of language, which constitutes the unconscious and delineates the contours of the worlds in which we believe we live. The journey of this book will take us across an Imaginary tightrope perilously suspended across an abyss between a vanishing subjecthood unconsciously encoded in the Symbolic pulsations of our language and an obdurate objecthood indescribably embedded in the Real pulsations of our body. And, to leap in a single bound across this internal chasm of mind and body, 'art' will be the general name offered here for many of our most precious cultural practices that may help to stabilise the rope and save us from falling into the void.

Freud acknowledged frankly that his study of Leonardo da Vinci might be nothing other than a psychoanalytic novel. In seeking to understand the motivations of the artist he admired, he admitted that he might have been duped into error by the enigmatic tale of a bird in the mouth and the enigmatic depiction of a

woman's smile. But if the maternal interpretation of the smile was not the historical truth of Leonardo's art it was a monument to psychoanalytic theory itself, for Freud used that smile to construct a scenario of ambivalent affect in which mother and child cleaved together and were cleaved asunder as well.

From the Desire of the Mother to the Name of the Father

What is the enigmatic Desire of the Mother as theorised by Lacan? What does the painted woman known as the *Mona Lisa* want in smiling at me in that ambiguously alluring yet alienating way? And what do I want from her in ambivalently facing and defacing her smile in order to bring her close and at the same time to keep her at bay?

If the anxiety of castration was first mobilised in the baby boy by comparing his little penis with the maternal phallus that he imagined to be lacking, then perhaps her unspoken desire was for him to be that Imaginary phallus for her so as to make good that lack. It was in the face of the mother's invitation or threat to reclaim the child as her own lost object that the child required a champion to protect him from that fate and, equally, from his own desire to embrace that fate. In the traditional family the one who exercised the function of separating the child from the mother was, of course, the father – he who had the culturally mandated task of stepping in and saying an unequivocal 'No' to the double-sided Desire of the Mother, hers for the child and the child's for her. In desiring his mother for himself and thus fearing the castrating punishment of his father, Little Hans was, in Freud's words, a little Oedipus, modern heir of the man of ancient myth who killed his father and wed his mother. According to Lacan, the father of Little Hans did not fulfil his duty to negate the private Desire of the Mother by offering the child an alternative identification with the Name of the Father on which the family's public identity was based. This ineffectual father did not do his duty early enough or fully enough in the twin case histories of Little Leonardo and Little Hans.

At stake in Freud's psychobiographical interpretation of a childhood memory of a renaissance genius was nothing less than the autobiographical proclamation of the genius of Freud himself in his signature invention of the Oedipus complex, in which tragedy ensued when the son murdered his father and married his mother, whether in mythological deed or in psychological fantasy. The preferred outcome was otherwise. In the Name of the Father the child must learn to tear himself away from the seductive Desire of the Mother, to identify himself with the father's naysaying to incestuous desire, to renounce the impossible burden of being the Imaginary phallic object that the mother lacks, to accept the Symbolic promise of becoming a father in the future, but only after having waited his turn. But in leaving his smiling paintings unfinished Leonardo had remained transfixed upon the mirror stage of the nursery, failing to take responsibility for his paintings' care just as his father had left him to linger too long in the embrace of a mother who lacked a lover and who thus became the enigmatic seductress of her son's uncomprehending desire. That was the explanation of the riddle of Leonardo's art and character as proposed by Freud, but it was not altogether what motivated the commentary of Lacan, to whose alternative articulation of the question of art and psychoanalysis we now turn.

Chapter 2

The *Da Vinci Code* according to Lacan

Whereas Freud looked to the unconscious fantasy of an individual artist in order to throw light on the singularity of his works, Lacan looked instead to works of art in order to exemplify the universal structures of mind and body that he hoped to articulate in the course of his psychoanalytic teaching. Freud's treatise on Leonardo took the biographical form of the monograph, in which the images and themes of an artist's works were meant to be illuminated by the facts – in this case, the allegedly unconscious facts – of the artist's life. For his part, Lacan discussed Freud's study of Leonardo at the end of a series of lectures in 1957. I will have more to say about the pedagogical circumstances of the seminar that Lacan conducted for almost thirty years, but for the moment let us take a brief look at this early phase of his teaching.

From Ego, Superego and Id to Imaginary, Symbolic and Real

In his first year of public teaching, in 1953–4, Lacan focused on Freud's essays on psychoanalytic technique. Lacan took pains to distinguish between two orders of experience encountered in the treatment of patients: the domains of deceitful images and truthful words that he called the Imaginary and the Symbolic. At this time Lacan's contributions to international psychoanalytic debates were rooted in his distinction between the Imaginary (or image-based) and Symbolic (or word-based) ways of structuring human experience upon the formless ground he called the Real. In this shifting dialectic of mute materiality, frozen images and mobile

words Lacan provides us with a rich triple paradigm for differentiating the physical materials, illusory forms and inferred meanings of works of art.

Lacan saw the Imaginary register as consisting in the individual's largely conscious but distorted visualisations of Self and Others that Freud had situated in the so-called Ego (in German, *Ich*, or I). In *The Ego and the Id* (1923) Freud had postulated a psychic apparatus of three distinct agencies. The Id (*Es*, or It) was the hypothetical site of the drives (*Trieben*), ideational representatives of the human organism's primordial instincts for nourishment, sexual attraction and aggressive self-protection. The Ego took on the difficult task of reconciling the demand of the drives for immediate pleasurable discharge with the postponements and constraints imposed upon the individual by the demands of society. These demands were brought to bear upon the partly conscious, partly unconscious interplay between the Ego and the Id by the so-called Superego (*Über-Ich*, or Over-I), the internalised imperative of social norms. This Freudian triple mapping of the psychic apparatus can be seen roughly to correspond to the Lacanian triad of the Imaginary (Ego), the Symbolic (Superego) and the Real (Id).

It was Lacan's distinctive contribution to the theory of the Ego to propose a visual scenario by which the Ego first came into being. Based on the alien but alluring images glimpsed in the mirror in childhood, the Ego was seen by Lacan to be crystallised in response to the admiring behaviour of the mother and to the actions of admired counterparts such as older siblings with whom the individual subsequently came to identify both in opposition and in emulation. We can see this formative interplay at the mirror of mother and child in numerous works of art across the centuries, notably in the late eighteenth-century colour woodblock prints by the Japanese master Kitagawa Utamaro and in the paintings, prints and pastels of the nineteenth-century American impressionist Mary Cassatt. In contrast to this private maternal preserve, the

Symbolic order was said to be constituted by the child's introduction to the public world of cultural meaning that was associated by Lacan with the father's speech. For the patients who came to speak to Lacan of their intransigent sufferings of body and thought, the motor of the cure was the uncensored outpouring of their words in the presence of the analyst. Punctuated enigmatically by the unpredictable interventions of the analyst, this mobilisation of signifiers was meant to generate new sets of Symbolic meanings so that the patient might move beyond the maternal idealisations and fixations of the Imaginary Ego.

In the second year of his seminar Lacan continued to elaborate upon Freud's theory of the Ego. Lacan insisted on the alienating implications of the child's discovery of its Ego as an alter Ego reflected in the image of the m/other of the mirror stage, a stage (in French, *stade*) that was at once a passing phase of childhood development and a lifelong arena or stadium of psychological conflict. In order to clarify the complex mirror-stage dynamics of self and other, Lacan returned to a distinction that Freud had not fully developed between two aspects of the Superego: on the one hand, there was the ideal Ego of the Imaginary other that the emerging Ego aspires to be like; and, on the other hand, there was the Ego-ideal, the position of Symbolic speech from which the aspiring Ego wished to be judged as wholly exemplifying its ideal. At its core the Ego was split, alienated from itself as an alter Ego, constructed on the basis of a visual model found outside itself. To add insult to injury, the Ego was oriented toward an impossible project of ideal self-fashioning with respect to which it could never be judged as anything other than unsuccessful and incomplete.

The dual relation between the aspiring Ego and the alienated Ego was thus a duelling relation as well. Within the individual there loomed a tension-packed stand-off between the internalised alter Ego – the me I see myself as being – and the image of the ideal Ego or mirroring other – the me I want to be and can never be. In order to dislodge the individual from this paralysing visual

face-off Lacan instead endorsed the pacifying relation of the speaking subject with another Other, the Ego-ideal. Lacan spelled the first other, which was visualised as a counterpart and rival in the mirror, with a lower-case 'a' for the French word *autre*. The second Other he spelled with an upper-case 'A' for *Autre*, the image-less Other of language's impersonal storehouse of words in which we dwell even when we are expressing our most personal selves. It was the widely held delusion of an inner self based on the Imaginary other of the mirror stage that Lacan was most at pains to combat. His alternative champion was the subject of the unconscious, the Symbolic subject of speech. We see his friend Picasso alternating in the portrayal of his teenage mistress Marie-Thérèse Walter between the anxiety of confronting the Imaginary other reflected in *Girl Before a Mirror* (1932, Museum of Modern Art, New York) and the appeasement of identification with the Symbolic Other of language in *Girl Reading at a Table* (1934, Metropolitan Museum of Art, New York). In the latter painting a blackened mirror hangs on the wall behind her flower-wreathed head.

In his insistence on the dangerous duel of self and other in the Imaginary dimension of the Ego, Lacan was extending Freud's formulations on the self-loving and self-loathing narcissism of the Ego that we encountered in the story of Leonardo. Lacan claimed to be faithfully returning to Freud's fundamental theories in respect to the meaning-making resources of the Symbolic dimension of the subject in language through which Imaginary misperceptions might be dispelled.

Schema L

In a memorable diagram addressed to the avid eye of visual culture, Lacan schematised the troubled crossing of the Imaginary and Symbolic axes of conscious and unconscious experience. Called Schema L on account of its resemblance to the capital letter lambda in Greek, this crossing will help to envision a key lesson

of psychoanalysis for both novice and expert users of images and words. In the diagram, one of many blackboard aids drawn by Lacan during his lectures, the Imaginary relation is fixed in a straight line of affectual reciprocity between the alienated alter Ego of the individual, denoted as (a), and the unattainable image of the other, denoted as (a'), the ideal Ego with which it vainly identifies and seeks to resemble and replace. It might help here to visualise a painter (a) looking at his reflection (a') in a mirror in the process of painting a self-portrait, a complex triple scene famously depicted on a 1960 magazine cover of *The Saturday Evening Post* by the American illustrator Norman Rockwell. As a result of the illusory and elusive face-off with his Imaginary mirror image, the self-portraitist must sacrifice that major part of the authenticity of his Real and Symbolic being that is not adequately expressed in his external appearance. But the physically awkward sixty-six-year-old Rockwell is supported at his easel by an array of Symbolic attributes of artistic glory, including a gilt American eagle and a golden armoured helmet. Quizzically bespectacled in the mirror but clear-eyed and glasses-free in the portrait, Rockwell attests that the recording of mere Imaginary resemblance need not be all that a self-portraitist aspires to portray. Unlike the glassy vacancy of the mirror, Rockwell's white canvas proudly bears the black block letters of his name.

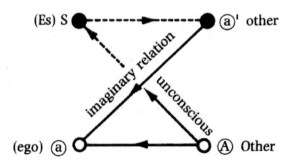

Crossing the Imaginary vector of the alter Ego facing the mirror image of the ideal Ego in Lacan's diagram (a–a') is the interrupted plane of the Symbolic relation (S--/--A). This vector attempts to traverse the gap between the individual Subject (Sujet) of speech, denoted in French and English as a capital 'S', and that Other place of the Ego-ideal designated by the capital letter 'A' (for Autre), the never completely excavated archaeological site of the buried treasure trove of our artefacts and language. To traverse this gap between Subject and Other the interrupted vector S--/--A must leap over the Imaginary wall of language, in which the unconscious subjective connotations of words are consciously congealed into brick-like units of objective denotation. The initial 'S'-sound of the name of the unconscious Subject of free speech puns upon the German sound of *Es*, Freud's ordinary daily word meaning 'It' that was misleadingly Latinised by his English translators into the scientific-sounding word 'Id'. Lacan's retranslation points to an indwelling within the speech of the human being of an unconscious Id-driven urgency that results from the loss of immediacy of instinctual life.

For the self-portraitist at the mirror, the equivalent of the unconscious address of the subject to the golden storehouse of language (S--/--A) is the exhibition of his or her painting in the Virtual Museum within which self-portraits by the great masters appear alongside his or her own. Tacked onto Rockwell's canvas are colour reproductions of self-portraits by Albrecht Dürer, Rembrandt van Rijn and Vincent Van Gogh, as well as a surrealist portrait by Picasso of a female model with the painter's profile peeking out behind her from a mirror on the wall. For it is to the words and images of our collective treasury of language and art and their inherited forms of meaningful expression that the speaking or painting individual is unrepayably indebted if he or she is to express the singularity of his or her being by means of a unique selection and combination of images or words.

With his diagrammatic image of the criss-crossed and star-crossed relations of the seeing Ego, the visualised other, the speaking Subject, and the mute Other of language, Lacan was ironically showing us that there is more to our being than may be seen in a single mirror image, that there is more to our being than will ever meet the instantaneous glimpse of the eye. In this visual diagram Lacan was telling us that it is only in the intersubjective and mobile medium of speech that psychoanalytic treatment – or artistic practice – may hope to restore to the patient-painter the unfolding potentiality of our fullness of being in time. We may be inescapably alienated from our primordially embodied experience in the words and images of others, but it is, paradoxically, only in the transpersonal linguistic and artistic discourse of the Other that we can get back some scrap of the vitality we feel ourselves to have lost.

In the third year of his public teaching Lacan returned to Freud's writings on psychosis in order to dramatise the malady of language that afflicted those who suffered from external persecutory voices rather than the guilty internal recriminations of neurotic illness. In the case of neurosis, the individual's impossible attempt to be the Imaginary fulfilment of the mother's imputed desire for the phallus may be overcome through identification with the father's forbidding of incestuous desire that Lacan called Symbolic castration. This process is not, however, without symptomatic residue. On the one hand, the hysteric repeatedly re-enacts the Imaginary wound of the mother's phallic loss in her own bodily malfunctions, thus resisting the paternal regulation of the roles of the sexes and putting the uncertain question of sexuality directly to the test: 'Am I a woman or a man?' On the other hand, the obsessional stages fantasies of paternal phallic potency in the form of compulsive rituals or recurrent thoughts that insist upon the father's authority and thus avoid confronting the insoluble questions of life and death: 'To be or not to be?'

In both the hysterical and obsessional forms of neurosis I lose by giving up the illusion of being the Imaginary phallus of the mother. I grieve for my loss in the unconsciously meaningful suffering of my symptom in body or mind, but at the same time I gain a Symbolic power of negation over the mother's enigmatic desire in my fledgling capacity as an individual speaker of the collective discourse associated with the father's wider role beyond the Imaginary confines of the nursery. In psychosis this critical father-function is not adequately performed in the name of separating the subject from the Imaginary drama of the mother's desire. This failure of Symbolic castration and its enabling accession to subjecthood may lead to paranoid fears of dismemberment or delusions of phallic omnipotence, but the crucial component for Lacan was the lack of the phallic signifier of paternal negation that might counter the regressive pull of maternal desire. In French the Name of the Father, *le nom du père*, is sounded just like the father's 'No', *le non du père*.

In the presence or absence of a Symbolic identity made of nothing but a No and a Name (Non/Nom) lies the fateful difference between the neurotic's relatively successful management of un-acceptable desire by means of obsessional thinking or hysterical symptom formation and the much more disastrous mental illness of psychosis. Whereas the neurotic possesses a sufficiently stable form of identity for it to be the subject of extremely vexing questions, the psychotic's lack of such an identity forecloses on the very possibility of meaningful conversation with others within the fundamental framework of the Other's social norms. I am first and my M/other is second, but we can converse only by way of the Other/Father of language that is our shared third. And so we see the solitary self-portraitist labouring on the surface of the canvas, anxiously positioned between a visual likeness seen in the nostalgic maternal mirror and the uncompleted painting still to be shown to the paternal Other. Real corporeality, Imaginary love, Symbolic recognition. Me, Mommy, Daddy. Now we are Three.

Lacking a stable identification with the anchoring signifiers of the social realm of the father, the Symbolically deficient world of the psychotic is pulled back into the lethal gravitational pull of the omnipotent phallic mother of terrifying Imaginary fantasy. Just this sort of vampiric fantasy was expressed across the ages in the troubled response of many male writers to what they saw as the *Mona Lisa*'s blood-curdling smile. According to Lacan, this anxious fate of maternal dominance and paternal inadequacy was shared at least in part by Leonardo. Unlike the internally riven world of the psychotic, however, Leonardo's world was held more or less together through the structures of art by means of which Symbolic representatives of Mother, Father and Self were precariously fixed in place. Near the end of this book we will see how Lacan, in his late seminar on the revolutionary verbal art of James Joyce, came to speak of the work of art as a fourth term providing the artist with a crucial semblance of self-consistency by tying together the otherwise dissociated orders of the Imaginary, Symbolic and Real.

From the Imaginary Mother to the Symbolic Father

Lacan offered his audience an extended discussion of Freud's account of Leonardo during the final lecture prior to the summer break of his 1956–7 seminar on object relations. Unlike the American psychoanalytic orientation known as Ego psychology which focused its theory and treatment on the strengthening of the defenses of the Ego against the disruptive pressure of unconsciously repressed sexual and aggressive drives, British object relations theory focused instead on strengthening an individual's interpersonal relationships against the fragmenting forces of the unconsciously internalised objects representing persons or parts of persons from his or her early life history. Rather than a loved or hated whole object such as the mother or a partial object such as the breast, the Frenchman was more interested in Freud's theory of the object that was not there, the

Imaginary maternal phallus that Freud had postulated as lost in the stories of the horse phobia of Little Hans and the bird fantasy of Little Leonardo.

In summarising Freud's account of the bird's tail inserted in the infant's mouth, Lacan questioned the superimposition of the two repressed wishes concerning sucking at the breast and sucking on the penis. Instead, Lacan insisted on reattributing these wishes to the Imaginary and Symbolic registers of Leonardo's unconscious mental life. At the Imaginary level Lacan interpreted Leonardo's memory of the bird's tail as screening from consciousness the overwhelming intrusiveness of his mother during the time she was bereft of Leonardo's father and took her baby as a compensatory love object. Lacan reinforced the hypothesis of damage done to the young Leonardo by the supposed selfishness of his mother's desire by referring not to the ancient folklore of the mother vulture, erroneously introduced by Freud, but to that of the mother kite which the artist described elsewhere in his notebooks as envious and abusive of her baby birds. Fully conversant with the scholarly challenges to Freud's interpretation, Lacan was here citing a recent article in the *Journal of the History of Ideas* by the American art historian Meyer Schapiro.

Lacan opposed to the idealised duality of mother and child in object relations theory his own insistence on the triadic nature of the mother-child relation as mediated by the lacking phallus. The Desire of the Mother was for something beyond the symbiotic embraces of her child, something lacking that was symbolically represented by the phallus of her lover, the child's father. By extension, the paternal phallus became the signifier of the Symbolic order as such, a verbal signifier that might fill in a Real void with an abstract word but was not to be visualised as a concrete thing. The metaphorical operation of replacing the Imaginary phallus of the Desire of the Mother with the Symbolic phallus of the Name of the Father was called Symbolic castration on account of its signifying cut into the lost substance of the Real.

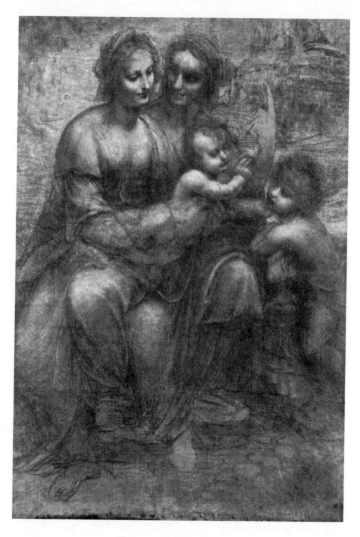

3. Leonardo da Vinci, *The Virgin and Child with Saint Anne and Saint John the Baptist* (1499–1500).

Think of the pen of the clerk inscribing your name on your certificate of birth. Think of the chisel of the sculptor incising your name on the stone of your grave.

Thus, unlike Freud, Lacan saw no blissful reconstitution of the Imaginary reciprocity of mother and child in the Madonna's smile. It was not her eyeing an Imaginary phallus in her baby son that would bring her joy. Instead, Lacan stressed the active role of the father's Symbolic phallus displaced within the figure of the lamb (like the horse of Little Hans) with which the Holy Child was playing. Standing for the crucifixion, the Lamb of God was also the name through which Jesus the playful son of Mary was transformed into Christ the sacrificed son of God. From the visible to the invisible, the Imaginary human trinity of Saint Anne, the Virgin Mary and the baby Jesus was superseded by the Symbolic divine trinity of God the Father, the crucified and resurrected Christ the Son, and the disembodied Holy Spirit signifying the universality of the Church and the eternity of the Soul. The necessity for this sorrowful but saving displacement was registered in the painting in the impassive face and hidden hand of Saint Anne, who prevents her daughter Mary from retaining her child in her desiring grasp, thus allowing the child to assume his Symbolic mandate as the sacrificial lamb for his flock. In contrast to Freud's Leonardo, who embraced in his art the Imaginary recovery of the mother's lost smile of desire, Lacan's Leonardo pointed to the Symbolic separation from her body that every one of us must make along his or her individual way toward an eventual death. Of course, neither Freud nor Lacan ever alleged that Leonardo would have been conscious of the unconscious meanings they discerned in his work.

The pointing finger

Lacan saw evidence of a displacement from the Imaginary relation to the mother to the Symbolic relation to the father not only in Leonardo's painting in the Louvre, but also in an earlier large

drawing or cartoon of this same subject in the National Gallery in London (1499–1500; Figure 3). Referred to in a footnote by Freud as a dream-like melting together of the bodies of the two mothers into a single hybrid fantasy, the drawing uncannily positioned the baby Jesus as if he were a marionette-like extension of his mother's body springing upward from between her legs. This Imaginary phallic signifier of the maternal body is supplemented by the Symbolically elevated index finger of Saint Anne pointing upwards beyond the frame of the drawing to the realm of God the Father, in whose name the sacrifice of Christ will have taken place. All of Lacan is in the following passage: 'This is something that images very well the ambiguity of the Real mother and the Imaginary mother, the Real infant and the hidden phallus. If I make of the finger its symbol, it is not because it crudely reproduces its profile, but because this finger, which one finds throughout Leonardo da Vinci, is the indication of that lack-of-being of which we find the inscribed term throughout his work.' In the finger that points to something unseen Lacan moved from the enigmatic question of the Imaginary maternal phallus – 'Do I see it or do I not?' – to the appeasing answer of the Symbolic paternal phallus whose invisible presence is necessarily a matter of pure blind faith.

Detachable from the body like the phallus and thus susceptible for appropriation as a Symbolic marker, the pointing finger of Saint Anne was made by enclosing the emptiness of the surface of the paper with the barest indication of a drawn line. As such it was a concise indication of the fundamental dilemma of human development, namely the indirectly inferred role of the father versus the directly observed role of the mother in the life of the child. The finger pointing beyond the frame tells us that in visual art there is always more than meets the eye. Any aesthetic experience in the realm of the senses is implicitly framed by the Symbolic contract of a shared social meaning that cannot be reduced to an empirical visual representation of the world. Here again is the split between the animal-eye of the perceptual organ

of sight and the human-I of the affectual organ of desire that in art Lacan called the gaze.

In his commentary on Leonardo, Lacan questioned the concept of sublimation upon which the edifice of Freud's psychoanalytic aesthetics was built. For Freud, Leonardo's sublimation was the achievement of a substitute satisfaction in his paintings of smiles for an unsatisfied unconscious wish to recover a love he had lost. Less focused on the individual psychology of the artist, Lacan saw sublimation as a general structure in society whereby the Imaginary world of present perceptual experience was covered over by a Symbolic grid of signifiers pointing to a past life of Real primordial being and a future path to a meaningful human death.

Secular scholars steeped in the scriptures of Judaism and Christianity, Freud and Lacan were non-religious heirs to a cultural tradition in which the Symbolic inscription of the Name of God the Father held sway over the Imaginary depiction of the Desire of the Mother Nature Goddess. But in their evident enjoyment of the Roman Catholic art of Leonardo both men were susceptible to the beauty of the mother's face. Freud was moved by the maternal mirage of androgynous bliss that Leonardo had narcissistically fashioned upon the faces of his male and female figures from Saint Anne to Saint John the Baptist, also in the Louvre. Lacan, however, was moved more by the sight of the saints' index fingers emphatically pointing to the invisible realm of heaven's gaze beyond the sensuous pleasures of the eye's vision. In spite of this potential paternal identification, Lacan nonetheless insisted that Leonardo primarily identified himself with the Imaginary m/other of a natural world of fulfilled physical bliss rather than with the Symbolic Other of corporeal death and spiritual commemoration. This maternal fixation, rather than homosexuality as such, was what Lacan referred to as Leonardo's inversion, a trait he identified in the artist's idiosyncratically reversed mirror-writing as if it were performed to be read not by the Ego looking into the mirror but by the idealised other looking

back at the Ego from the maternally mediated matrix of the mirror. In referring in his notebooks to his daily activities and artistic or scientific aspirations, Leonardo habitually spoke from the inverted Imaginary position of the little other in the mirror and addressed himself as 'You'.

In concluding this chapter I want to look again at Schema L (page 19), according to whose Imaginary and Symbolic vectors Lacan charted the mirror inversion of the renaissance master. At the upper left let us place the Symbolic lamb in the place of the unconscious subject of speech (S), which, like the sacrifice of Christ, the Lamb of God, must also undergo Symbolic castration. The Symbolic function is that of the Freudian death drive, inasmuch as the Real of the organism must be metaphorically put to death in order for it to gain access to its humanity by way of the grammatical workings of the inhuman mechanism of speech. Across the fragile Imaginary membrane of the mirroring gazes of the Madonna and Child (a–a' or me–you), the disembodied subject of speech must locate that Other space of the paternal dictionary, where it must find the impersonal terms of its Symbolic inscription (S--/--A, I--/--It). In Leonardo's painting this final resting place is occupied by the grave-like marker of the pointing index finger of Saint Anne.

The Symbolic axis (S--/--A) traverses Leonardo's schema from the lamb to Saint Anne; it commemorates the two superimposed deaths of Real corporeal loss and Symbolic inscription in the afterlife of cultural memory. After all, this is a painting made by a dead painter's hand, not sainted flesh. Interrupting the Symbolic axis of the painting is the Imaginary screen (a–a') upon which are projected the loving and sorrowing images of the Ego and its ideal mate, the Madonna and Child. We find ourselves seduced by the beautiful Ego in the smiling faces of the baby Jesus and his mother Mary, both miraculously impervious to corporeal decay. It was from the inverted feminine position of the ideal Ego of the Virgin Mary that Leonardo saw himself seen as an object, an alter Ego of

androgynous gender (a'–a). It was this reframing of the bodily Ego as the Imaginary object of desire of the feminine or feminised other that Lacan defined as Leonardo's act of sublimation, an act through which the renaissance artist transformed himself into an admired work of art. Carrying his paintings with him on his final journey, Leonardo ended his days, according to legend, in the paternal arms of the King of France.

For Lacan, Leonardo's Imaginary sublimation of the Ego in the deathless smile of the beautiful woman was achieved at a high price. Leonardo's Imaginary sublimation as the mother's cherished object constituted a denial of the father's truth that he was also the precious subject of unconscious desire and Symbolic speech.

Chapter 3

The Thing from another world

'Who are you looking at? Are you looking at me? In looking at me are you acknowledging me as the object of your desire, the beneficiary of your love, the victim of your lust?' These, and others, are the unanswerable questions we unconsciously pose to the staring eyes of the *Mona Lisa* and her myriad sister paintings, from wide-eyed Byzantine Madonnas to Edouard Manet's *Olympia* (1863, Orsay Museum, Paris), Pablo Picasso's *Demoiselles d'Avignon* (1907, Museum of Modern Art, New York), Willem de Kooning's *Woman I* (1950–2, Museum of Modern Art, New York), Andy Warhol's *Gold Marilyn* (1962, Museum of Modern Art, New York), Jenny Saville's *Branded* (1992, Saatchi Gallery, London) and Cindy Sherman's many untitled large-scale colour photographs of the 1990s showing herself looking out of the frame in the disguise of famous holy women and femmes fatales from the history of art. Am I the eye to whose view you wish to show yourself in the fear and fearsomeness of your gaze?

We want the work of art to confirm us in the wished-for unity of our being, we want the work of art to appear to want us to be its ideal viewer. But all this is an Imaginary illusion, because as we move aside and another viewer comes to stand before the work in our stead we come to realise that the gaze of the painting does not address us at all in the uniqueness of our own corporeal being. The painting's gaze addresses itself to an Other place, the empty Symbolic place of the spectator of art in which we see our subjecthood come and go. For an instant the work holds us with its

gaze, and our eye and I are jointly appeased. This was what Lacan called the principle of artistic creation: that the world we see in art is the world of our desire. The dilemma, however, is that the Imaginary world of our infant desire was misconstructed from the outset from the enigmatic traces of another's desire, perhaps the mother's, and therefore we never simply desire on our own.

Sublimation

For many years Lacan taught that the goal of psychoanalysis was to assist suffering individuals to sublimate their dissatisfaction. Their exceedingly difficult task was to renounce inhibiting ties to an Imaginary maternal paradise of lost bodily bliss by way of a Symbolic identification with the collective ideals of a particular social group. The induction of the novice into the norms of the group was traditionally the responsibility of the father, but this acculturating role could be performed by the mother herself in his name. The Imaginary object of incestuous satisfaction might thus be transformed into a Symbolic object of creative passion. The exemplary instance of the Symbolic transformation of impossible Imaginary demands is the work of art, which Lacan defined in a 1938 essay on the pathologies and sublimations of modern family life as an ordinary object erected into the light of astonishment. The subject might be nothing more than a lowly still life of pots and pans but its pictorial refashioning as the material signifier of an absent presence might transform the work into an amazing masterpiece.

In 1959–60, in the seventh year of his public seminar, Lacan devoted the majority of his lectures to the question of the work of art. Lacan affirmed that the Symbolic labour of artistic sublimation illuminated what he called the ethics of psychoanalysis, namely the analyst's duty to facilitate the articulation of the patient's impeded desire. The Symbolic articulation of unconscious desire in the course of psychoanalytic treatment offered the possibility of an art-like sublimation of the regressive allure of the inaugural,

inaccessible, intangible, invisible, impossible object of desire. Following Freud, Lacan called this mysterious object 'the Thing'.

The Thing

In his posthumously published *Project for a Scientific Psychology* (1895) Freud made the distinction that Lacan exploited in his *Ethics* sixty-five years later, between the representation of a thing (in German, *die Sache*) and another kind of thing altogether (*das Ding*), whose unrepresentable existence could only retroactively be inferred. The Lacanian *Ding* (in French, *la Chose*) was also related to the transcendental Thing-in-Itself (*das Ding-an-Sich*) of the German philosopher Immanuel Kant that, like God or the infinity of the cosmos, was posited as being beyond the perceptual capacities of human experience. For Lacan, the Thing was the retrospective name for that nameless entity of being that would have engaged the full scope of infantile experience prior to the acquisition of language. Thus, there was not yet a Thing as such until the time it would have become irrevocably lost when the immediacy of wordless experience first came to be mediated by words. The momentous result of this intrusion of the signifier into the life of the human organism was a splitting between conscious and unconscious representations, and the Thing became that spectral being which lingered in the unconscious as that which could not be named. In Harry Potter's world of wizards, Lord Voldemort (Full-of-Death) is the not-to-be-named Thing.

In Lacan's world of psychoanalysis, the mother was placed in the mythic position of the Thing. She was the Thing of the infant prior to its capacity for linguistic representation not because of her instinctual provision of corporeal satisfaction to her needy, dependent baby. The mother became the child's lost Thing when she frustrated its demands for her loving attention during a time of her own corporeal satisfaction, for example when she was eating, defecating or having sex. Such independence of maternal enjoyment would have been beyond the child's capacity to accept.

This self-absorbed, unavailable Thing would thus have become an object of discordant fantasy offering the child no satisfaction at all. In its withdrawal from the enclosed mother-child duality of corporeal need and urgent demand, the autonomously desiring Thing both provided the initial cause of an unassuageable desire and also constituted its unattainable object. This Thing that was also No-Thing situated the individual vis-à-vis a psychological space that might be made indirectly accessible through the Imaginary and Symbolic mediation of memorial images and words. But this Thing also situated the individual outside the inaccessible space of the Real, lying entirely beyond the grasp of its flimsy images and words. So what does this Thing have to do with the work of art?

In the formula for sublimation that Lacan repeated throughout the seminar, the work of art was seen to negate the apparent reality of things and raise everyday objects susceptible to word-and-image representation to the dignity of *das Ding*, the Thing, that lies beyond the capacities of representation. In its split between outer sound and inner sense, Lacan's Franco-German pun of *dignité/Ding* was itself a characteristic verbal enactment of the incalculable proximity and distance of this intimate yet wholly 'extimate' Thing, both inside and outside at one and the same time. Much of the doubleness and duplicity of Lacan's sublimated wordplay is lost when we read written transcriptions and translations of his spoken seminar. Like his friend and neighbour Tristan Tzara, the original Dadaist poet of the provocative spoken word, Lacan was a brilliant performance artist, and his oral seminar was his art.

If artistic sublimation enacts an appeasing play of words and/or images in place of a persistent blockage in sexual satisfaction, complete satisfaction nevertheless remains unachieved. The work of art provides a genuine substitute satisfaction for the lack of a successful sexual relation, but it does not thereby eliminate the permanent deficit of desire. In Lacan's view, Freud led many of

his followers in Ego psychology and object relations theory to underestimate the stubborn pressure of unconscious desire by maintaining that sublimation provided a change of aim for the sexual drive, for example from the body of the mother in neurotic fantasy to a picture's painted smile. In contrast, Lacan proposed that the crucial change in sublimation did not alter the aim of the drive from a forbidden object of sexuality to a socially sanctioned asexual substitute. Lacan affirmed that in the act of sublimation there was a reconstitution in fantasy of the object itself, a transformation of the object from its ordinary appearance into its extraordinary manifestation as the Thing.

Formula of fantasy

Lacan agreed with Freud that members of society took consolation from the mirages of art, but he did not attribute the power of art to the mere fact of social consensus. Rather, Lacan insisted on the force of the fundamental fantasy of artistic sublimation, whereby the subject of unconscious desire was safely positioned face to face with the inaugural cause and impossible object of its unrelenting corporeal drive. Lacan's juxtaposition of subject and object in the sublimated fantasy of the work of art was written in the quasi-algebraic form $\$<>@$. I hope that you will not be put off by the mathematical appearance of this formula, for I believe that it can be a very useful memory aid. I have no other aim in this little book than to intrigue you with the idea that this discreet secret formula may be all you need to know about Lacan and the work of art.

Lacan introduced the formula of fantasy during the fifth year of his seminar on the formations of the unconscious such as symptoms, dreams, slips of the tongue and jokes. In the following year he elaborated upon his cryptic formula in connection to Shakespeare's *Hamlet* when he placed the title character's famously obsessional question – 'To be or not to be?' – at the centre of the seminar on desire and its interpretation. Filling the blackboard with a puzzling series of diagrams featuring Greek and

Roman letters as well as symbols of his own invention, Lacan reproduced the so-called complete form of the Graph of Desire in a 1960 essay published in *Ecrits*, 'The subversion of the subject and the dialectic of desire in the Freudian unconscious'. The graph has been known, if not well understood, by English readers since its inclusion in the 1977 selected translation of *Ecrits*.

Graph of Desire

The graph offered Lacan's colleagues a memorable image with which to orient their treatment of patients who, like Hamlet or Leonardo, were inhibited in the enactment of their desire. As artists and art historians we need not grasp all the implications for psychoanalytic treatment that may be encoded in the Graph of Desire, but in my own practice of teaching and writing I have become convinced that crucial elements, such as the formula of fantasy, can help clarify fundamental issues at stake for us in the production and consumption of works of art. Although I will attempt to be clear, my explication of the symbols and vectors of the graph may be somewhat difficult to absorb. Please don't get anxious if you don't manage to take it all in on the first try, and just go on to the next section.

The Graph of Desire charts the emergence of the subject's desire as it intersects with the conscious and unconscious articulation of the desire of the Other in speech. Crossing the boomerang trajectory of the subject's arrow of desire are the twin trajectories of the desire of the Other running from Signifier to Voice and from Jouissance to Castration. The lower arrow running from the selection of the Signifier to its enunciation as Voice designates the level of spoken meaning where the conscious denotation of a statement is articulated. In contrast, the upper arrow from Jouissance to Castration, the definitions of which I defer for a while, designates the level of unspoken implication where the unconscious connotation of the statement remains obscure. It is in its fraught encounter with the mixed messages

of the conscious and unconscious desire of the Other that the subject's desire comes to be.

The subject's path of desire consists of a long, looping arrow often described as an upholstery stitch. Using a curved needle that pierces the fabric twice, the upholsterer sews down a strategically located button on the outer surface of a piece of furniture in order to stabilise the shapeless stuffing inside. It is by means of such a stitching together of interior and exterior elements that a more or less successful articulation of conscious and unconscious desire is made possible for the embodied human being that speaks. On Lacan's graph, the skewering movement of this needle of the self returns to its point of origin after passing through four logical moments – shown as four spatial levels – in the articulation of

desire. Some of the elements of the graph are already familiar to us from Schema L.

Starting at the lower right of the loop we find the symbol $, the split subject of the unconscious (in Schema L, 'S' for *Sujet* in French, *Es* for It in German and *Id* in Latin). This Subject is not present at birth, and it is only by means of the acquisition of language that it becomes the speaking delegate of bodily need. The urgency of its inborn need is represented immediately above the subject by the triangular Greek letter delta (Δ), which triggers the upward drive of desire. Born in a state of helplessness with respect to the satisfaction of its needs for nourishment and protection from the environment, the human infant will die unless it is nurtured by another, typically the mother or her surrogate. For the sake of its survival the as-yet speechless infant must learn to indicate its needs in the form of demands addressed to the m/other. This is the Imaginary m/other, experienced at first by the child as all-knowing, all-powerful, and wholly without lack. The face of the Imaginary m/other orients the infant subject in its understanding of desire. This primordial face is represented on the first level of the graph by i(a), for image of the other (*autre*, little other). In Schema L this is designated (a′) for the image in the mirror of the ideal Ego.

All but the most severely impaired human children eventually learn to express their needs beyond the mimicking of the mother's facial affect. The child learns to speak in the precisely articulated sounds of its mother tongue. This parental repository of language is represented on the second level of the graph by the encircled capital A (*Autre*, Other, Big Other). The upward line from $ to A repeats the Symbolic axis of Schema L (S--/--A), and, like it, it too is interrupted by the Imaginary axis of the mirror stage. In Schema L the Imaginary axis of rivalry and reciprocity of the alter Ego and the ideal Ego is represented as a–a′. In the Graph of Desire this Imaginary vector is drawn as the leftward line of force that impacts upon the lower-case letter m (*moi*, me) on the left slope of

the loop from the direction of the image of the ideal Ego – i(a). The ideal Ego is either the unified image of its body that the child sees in the mirror or the alluring image of the mother or some other that it takes as its model or counterpart. It is upon the reflected instance of this idealised other that it consolidates itself as an alter Ego, an alien persona or statue-like mask. A double self-portrait of 1922 by the Greek-Italian painter Giorgio di Chirico shows the anxious face-off between the artist's colourful living embodiment and his white marble bust, which gazes at him with blind eyes of stone (Toledo Museum of Art, Ohio).

Through the imitation of the language of its parents, the subject learns to articulate its bodily needs in the form of spoken demands. The discourse of m/other and child is represented on the second level of the graph by the vector that runs from left to right, from Signifier to Voice. We might think that the meaning of the subject's message would derive from its own choice of signifiers from among the available signifiers of its parents' language, but Lacan's understanding was just the reverse. The meaning of our messages is not determined by the vector of the authorial subject, running from left to right, but by the reverse leftward vector curving above it on the graph. According to this understanding of the retroactive structure of language, it is actually the other – the mother of the child, the reader of this book, the viewer of a painting by Picasso or a film by Fellini – who wields the power to determine what the subject's message will be taken to mean. This reverse vector of meaning runs from the encircled A, where the vocabulary and grammatical rules of the Other are to be found, back to the encircled locus labelled s(A), for signified of the Other. Here the m/other determines the signified (with lower-case 's') of the subject's Signifier (with upper-case 'S') in terms of the available signifieds of the Other (capital 'A'). The Big Other of Lacan is a twin of George Orwell's unseen Big Brother whose framework of permissible meanings constitutes the linguistic coordinates of the social and

political worlds – 'the War on Terror' – in which we are forced to live.

As children we articulate our needs as spoken demands by selecting our words from the parental storehouse of signifiers designated on the graph as the linguistic circle A. If we are to make ourselves understood, however, it is only the other with whom we enter into the pact of communication who will determine the meaning of our demand in the form of his or her response from within his or her own particularised circle of language – s(A). Although the emergent subject initially endows the m/other with the knowledge of what s/he and the subject want, the evolving subject begins to develop a sense of something that lies beyond its demanded satisfaction of needs as well as beyond its ability to provide for the m/other's own satisfaction. Lacan called this lacking or lost object the Imaginary phallus, and its absence is represented on the third level of the graph by the letter 'd', for unconscious desire.

Distorted by impossible images of full satisfaction of m/other and child, our spoken demands for love fail to fulfil the subject of affectual need. In the representation of corporeal need as spoken demand there remains the ineliminable residue of unconscious desire. The lower half of the graph corresponds to the Imaginary order and the conscious demand for love from the mother and other counterparts of the mirror stage (including the Imaginary loving father). In contrast, the upper half of the graph designates the Symbolic register and the unconscious articulation of desire for a nameless something beyond what we currently have. This something else is whatever stands in for the Symbolic phallus as that which would represent someone as complete. Lacan claimed that we learn to desire this nameless otherness by identifying with the apparent freedom of the father to transcend the maternal privacy of the home. So we leave home to create a new name for ourselves in the public world, and we sign our works of art with our uniquely self-authorising names.

The Name of the Father is the Symbolic function of saying 'No' to the Desire of the Mother to keep her child at home and 'No' to the Desire of the Mother on the part of the child who wants to be kept at home as well. The affirmation of this limit-setting and boundary-breaking 'No' might be performed by an actual or surrogate father, by an actual or surrogate mother's sexual or non-sexual partner of either sex, or indeed by the mother herself in her Symbolic role. However articulated, this paternal 'No' leaves behind a remainder of unsatisfied desire for the intimacy of the nursery. Regardless of satisfactions received, this unconscious desire maintains its constant impetus or drive.

The strange formula at the upper right of the graph – $\$<>D$, the Subject in relation to Demand – shows the subject relentlessly driven to try to be what it can never be: the missing phallic object of completeness that the M/other seems to demand. Unlike the subject's confrontation with the Imaginary partner of the mirror stage that is figured on the second level of the graph in the face-off between the alter Ego and the ideal Ego, the fourth-level formula $\$<>D$ designates a far more traumatic, faceless encounter. This is the formula for what Freud and Lacan called 'the drive'. It is the encounter between the subject of language and the internalised voice resounding in its head that incessantly makes upon it a series of ever more rigorous, impossible demands. This is the cruel voice of the Superego, the implacable command of the murdered mother, made manifest in the homicidal body of Norman Bates in Alfred Hitchcock's *Psycho* (1960).

The dissatisfaction that the unconscious subject of language is forced to endure in its failed encounter with its relentless corporeal drive is labelled 'Castration' on the top level of the graph. This castration is Symbolic because it does not cut directly into the incestuous substance of our lost mother-child flesh. Instead, Symbolic castration cuts into our anxious representations of that joint flesh by means of the surgical signifiers of language. Symbolic castration is the price paid by the newly minted human

subject as it leaves behind the natural enjoyment of its wordless mother-child body and steps into its severed, ill-fitting skin of words. Michelangelo represents himself in the disguise of Saint Bartholemew holding his own horrific suit of flayed skin in the Sistine Chapel's fresco of *The Last Judgment* (1535–41). Emptied of natural vitality, I am $, the subject split from its substance by the signifier's unnatural cut.

At the top of the Graph of Desire the flight of the arrow from Jouissance to Castration and back again represents the unconscious connotation of speech. This is an elusive supplement to the conscious denotation of speech represented by the lower arrow from Signifier to Voice. Just as the retroactive movement from Voice to Signifier represents the power of the parent to enforce his or her meanings upon the subject, the parallel movement from Castration to Jouissance represents his or her impotence to do so. Originally it was the omnipotent and omniscient Imaginary mother who was believed to have the power to determine the signified of the message fashioned by the child from the signifiers of the Other – s(A) on the second level of the graph. In the strange fourth-level formula S(\bar{A}), however, we encounter the unconsciously known truth that the m/other is not whole, that there is a Signifier – the Symbolic phallus – that she too lacks to render her complete. It is not only the self but also the m/other who is castrated, and the Symbolic father as well. Still more, the Big Other of Language and Law is itself not whole, for there is always a missing signifier – something more to be said, more words to be invented, more works of art to be made. There is no One final Word to bring an end to the dynamic desire to create something more, something else, something new. So Lacan strikes through the capital letter 'A' of the Other with a diagonal slash of the pen. The sham omnipotence of the Other is annulled in the barred Other of lack. The emperor is naked in his suit of no clothes.

Because language can only partially express the corporeal urgency of the subject's needs, its enunciation of signifiers will

inevitably disclose a realm of dissatisfaction beyond what its words can say. It is this unconscious connotation of the message of the subject that is interpreted by the psychoanalyst on the fourth level of the graph. Unlike the m/other on the second level of the graph who stabilises the meaning of the subject's signifiers in the leftward return movement from A to s(A), in the retroactive movement from $\$<>D$ to $S(\cancel{A})$ the analyst liberates the silent and stammering speech of the subject from its stalled and stifled meanings. This is the movement from the Castration that is produced under the pressure of the Other's unfulfillable demands to the Jouissance that is procured in the jubilant recognition of the Other's constitutional lack.

Jouissance

The encircled locus $S(\cancel{A})$, where the phallic Signifier of completeness is lacking, is the unconscious focus of the Other's lost corporeal Jouissance. Just what is Jouissance? An obsolete word in English deriving from the word meaning 'enjoyment' that retains its currency in French, 'jouissance' in the Lacanian sense implies both the enjoyment of rights of property and the enjoyment of sexual orgasm in which a tolerated pleasure may get out of hand and become an intolerable pain. In the unconscious circulation of speech from Jouissance to Castration the subject moves joyously from lost possession to desired dispossession around and around, again and again.

In the punning sounds of jouissance Lacan asked us to hear the made-up word *jouis-sens*, the sense or nonsense that resides beyond the enjoyment of the organ in the enjoy-meant of speech. Inspired by the name of Freud, the meaning of which is joy in German, Lacan may even have heard in jouissance a certain *juif-sens* or Jew-essence, a playful practice of reading exemplified both in the Rabbinic interpretation of the Hebrew letters of the Torah and in the Jewish jokes in Freud's 1905 book, which Lacan often retold in the course of the seminar. Also heard in jouissance is the

obedient response *j'ouis*, French for 'I hear', as if the subject of speech unconsciously acknowledges a call coming from beyond the conscious meanings of language, from the realm of the meaningless cries and sighs of its own mythical animal copulation. In order to take up places as speaking beings in society we must endure the Symbolic castration that incises a cut or limit upon our corporeal enjoyment. Nevertheless, in our sensuous savouring of the sights and sounds of the signifiers of reading, writing, rapping and reciting, the subject of the unconscious sustains the sublimated enjoy-meant of speech itself.

The movement from Jouissance to Castration represents the loss of primordial enjoyment that the human body forfeits in its accession to human subjecthood. The countermovement from Castration to Jouissance restores something of this loss in the corporeal enjoyment of speech. Nevertheless, in the incompleteness of the signifying chain the Other has been revealed as lacking. The unconscious fantasy of the subject is to become the object to fill this lack, and thus beyond the lack of the Other on the Graph of Desire Lacan writes the formula of fantasy – $\$<>@$. Located on the third level of the graph, this is the uniquely personal fantasy that the subject of unconscious desire must traverse on its looping path of self-discovery.

To sum up: the arrow of desire of the human subject – $\$$ – is shot into the air from the deep, dark delta of organic need – Δ. The arrow of subjectivity seeks to pin down the desire of the m/other as an Imaginary ideal Ego – i(a) – by affixing itself to a series of Signifiers from the Symbolic father's store of words – A. Forging its way upward, the arrow of desire – d – falters in the turbulent wake of the Other's impossible Symbolic demands – $\$<>D$. Freed to return to its point of origin by the disclosure of the Other's ultimate lack of force – $S(\cancel{A})$ – the arrow of desire follows the path of unconscious fantasy – $\$<>@$ – as it seeks to make good that lack. The Symbolic scenario of the fantasy aims to bridge the gap between the dis-embodied subject of unconscious speech and the abject shred of lost

mother-child embodiment that fell away under the blade of the Signifier that severed it from the Thing. Falling to earth with accelerated momentum, the arrow of desire pierces the m/other's pretence of stable meanings – s(A) – thus releasing the *moi* – m – of the alter Ego from its mirror-stage enslavement to a false self-image. At its point of terminus in the burial ground of the human subject, the arrow of desire arrives at its own grave marker, its commemoration as Symbolic Ego-ideal – I(A) – in the pure inscription of a Name. So goes the flight of the unconscious subject of the Signifier, from womb to tomb, from Imaginary mirror to Symbolic stone.

From maternal ideal Ego to paternal Ego-ideal

The Symbolic identification with the Name of the Father positions the subject of speech at a safe distance from the mesmerising immediacy of the maternal Thing. The lower-case i(a) represents the alluring but deceptive Imaginary realm of fulfilled maternal love. This unstable position of the maternal ideal Ego is sublimated and provisionally stabilised by the stitching in place of the upper-case I(A) of the paternal Ego-ideal. Here the immediate perception of the Imaginary organ of the eye is exchanged for the mediated conception of the Symbolic letter I. Here the creative inference of a paternal order of culture beyond the natural realm of the mother is sustained. This is the crucial difference between Freud's Imaginary reading of mother-child bliss in Leonardo's *Madonna and Child with Saint Anne* and Lacan's Symbolic reading of the elevated index finger of Saint Anne pointing toward God the Father's spiritual realm.

Along its circuitous path of desire the abstract subject of paternal denomination repeatedly comes face to face with concrete remnants of its lost embodiment. These remnants bear the traces of its split into the bodiless subject of language, on the one hand, and, on the other, the lost joint embodiment preserved in the fantasy of the primordial maternal Thing. The cryptic formula of fantasy – $\$<>@$ – is an uncanny juxtaposition of a

lack and a void, a hole in being that permits a view of being's lost whole.

In the grip of the fundamental unconscious fantasy, the empty subject of linguistic meaning is for an instant held in place in the face of the lost object of corporeal being. Facing the materialised fantasy of the work of art, the thoughtful subject of unconscious desire is temporarily able to fuse with the thoughtless subject of the sexual drive. Hence the vibration of bliss and menace in a painted lady's smile that for the past 500 years has been held in fragile equilibrium by the engine of perpetual desire that is the work of art.

In an echo of Freud's offering of the *Mona Lisa* as the pictorial paradigm of the sublimated Thing, Lacan's primary example in his lectures on sublimation was the inhumanly beautiful woman of courtly love. This frozen statue of female inaccessibility provoked the poetic devotions of her male suitors and at the same time spared them from the impossibility of any permanent sexual satisfaction. She was not the Imaginary Mother who had become the unfairly forbidden object of the Symbolic Father's threat of castration. Rather, she was the monumental primordial Thing with whom no reciprocal bliss of Imaginary enjoyment could have been possible for the tiny human infant. It was thus that the Symbolic operation of paternal castration came to the fore to save the newly created subject of language from its unspeakable fascination with the maternal Thing.

The Kleinian mother

In situating the mythic body of the mother at the place of the Thing Lacan acknowledged the precedence of the Austrian psychoanalyst Melanie Klein, who spent most of her career in England. Her writing and teaching was the primary source of object relations theory. Klein was the psychoanalyst of the generation after Freud whose work was perhaps most respected by Lacan, though this regard was generally expressed as strong disagreement. As

summarised by Lacan in *Book VII* of his *Seminar*, the Kleinian theory of sublimation saw art as performing a restitutive function in which fantasies of aggression toward the mother's body were repaired in the formal medium of the work. Lacan objected to this formulation as falsely situating the work of art at the Imaginary level of the maternal mirror stage of self-and-other reciprocity. As we have seen, Lacan located the work of art at the Symbolic level of identification with the figure of the father – indeed, the dead father – and the cultural order of the Other beyond the family that he traditionally represented.

Lacan also criticised the Kleinian view of art as ahistorical. Lacan insisted that the work of art was always to be understood historically and that the sublimations of a twentieth-century artist would necessarily differ in artistic style from those of an artist of another time and place. Unlike Freud, who cared little for the art of his century and whose conservative tastes in art Lacan challenged, the Frenchman prided himself on his collection of works by avant-garde Parisian contemporaries such as Picasso, whom he had known socially since the surrealist years of the 1930s and for whom he had served as physician and even as psychiatrist to the artist's mistress Dora Maar. Lacan often quoted Picasso to the effect that he, like the artist, did not seek but, rather, found. This was another way of stating his axiom of the split between the eye and the gaze, whereby the world appeared to him not as an object of dispassionate observation but as a disruptive force field of desire that grabbed him irresistibly in its passionate web. Lacan also quoted the doctrine of the chance finding of the object of 'mad love' (*amour fou*) by another avant-garde contemporary, the surrealist writer and polemicist André Breton.

In his lectures on sublimation, Lacan paid close attention to a landmark article of 1929 by Klein, 'Infantile anxiety-situations reflected in a work of art and in the creative impulse'. In this essay, Klein presented the story of a depressed woman who turned to painting in order to fill up an empty space that she felt within.

Klein understood this internal void as the product of the daughter's aggressive attacks in fantasy upon the mother's body for having been denied the bodily and emotional sustenance she craved. Instead of stressing the role of maternal inadequacy and infantile aggression, Lacan saw the empty space described by Klein as the result of the linguistic severing of the child from the mother's body. As a consequence, the child created the fantasy of an internal corporeal void and of a lost maternal object that had to be refound in order to fill it up.

Art and emptiness

In insisting on the emptying out of a Symbolic void from the unbroken continuum of actual experience, Lacan also cited the example of the artisan's vase that created a void and the possibility of filling it. Lacan appropriated this example from a 1951 essay entitled 'The Thing' (*Das Ding*) by the German philosopher Martin Heidegger, whom he met in 1955 and whose notoriously dense writing he translated. Combining the insights of Klein and Heidegger, Lacan proposed his own startling definition of the work of art: 'All art is characterized by a certain mode of organization around the emptiness of the Thing.'

According to Lacan, religion avoided this primal emptiness by filling it with God. Science rejected this void, attempting to fill it with the equations of natural law. Art alone manifested the emptiness of the Thing, in the illusoriness of its forms. Lacan had sought to specify this constitutional emptiness on the Graph of Desire in the formula $S(\cancel{A})$, the lack of a definitive Signifier in the language store of the Other to answer one's own most fundamental questions of existence.

From the palaeolithic paintings of the animals of the hunt on the stone walls of the caves of Lascaux (15,000 BCE) to the renaissance peopling of the frescoes of the churches of Rome (C. 1500), art has endlessly emptied out a sacred space only in order to fill it up. Insofar as we believe in a transcendental presence that

guarantees the truth of the artistic representation we remain at the level of the Imaginary, imagining that there is an Other, a god in the temple, who can supply the answers that we demand. We accede to the Symbolic level of understanding only when art presents us with the means of recognising that its impressive perspectives are constructed illusions, as in the stage set of the Olympic Theatre in Vicenza (1580) by the Italian architect Andrea Palladio. In the Symbolic art that Lacan admired, there was an affirmation of the opening up of an empty space as necessarily prior to the superimposition of any representational markings upon it, no matter how convincing these Imaginary illusions may be to the beholder's eye.

Anamorphosis

Lacan likened the self-negating illusionism of art to the illusion-rupturing practices of psychoanalysis. As a key example he introduced the audience of his seminar to *The Ambassadors* (1533; Figure 4) by the German painter Hans Holbein the Younger. The painting is a full-length double portrait depicting two richly attired men in the prime of life, Jean de Dinteville, French ambassador to England, and his friend Georges de Selve, Bishop of Lavaur, standing on a marble mosaic floor against a patterned wall hanging of deep green brocade. The ambassadors' boastful mastery of their international network of religious, political, economic and scientific interests is projected in the wealth of objects laid out upon the two tiers of a tall, carpet-covered table, upon which they confidently lean. Prominent among these objects are celestial and terrestrial globes, a sundial and other instruments of scientific measurement, a lute and a case of flutes, and a book of religious hymns and a mathematical text. Almost unseen in the upper-left corner of the painting is a small silver crucifix that interrogates the worldly vanity of the two ambassadors. And, at the bottom of the painting, diagonally set between the feet of the two men, there looms a large, illegible object that challenges still further the

4. Hans
Holbein, *The
Ambassadors*
(1533).

perspectival stability of the scene. The
proper form of this illegible object becomes
apparent only if one moves sharply away
from the standard frontal view in order to
take up an unconventional viewing position
beyond the painting's right-hand edge.

This sidelong gaze at the painting repeats
the structure of psychoanalytic treatment,
in which the analyst does not face the eyes
of the patient but instead listens to the

signifiers of his or her unconscious discourse from an unseen position beside the couch on which the patient reclines. Similarly, it is only from the side of the painting that the enigmatic formlessness that Lacan compared to fried eggs is resolved by the perspectival trick known as anamorphosis into an eerily hovering image of a huge human skull. The skull may be an uncanny signature of sorts, for in German Holbein's name means 'hollow bone'. Indeed, the overall iconography of the painting relates it to the genre of still life known as vanitas, in which the vanity of transient flesh is humbled by the changeless face of death. By means of naming the frontally indeterminate visual blob a skull or death's head, the Symbolic order of religious iconography obliterates the Imaginary illusion of a directly perceived naturalism. This act of naming opens up a radically new space for human meaning, like that of Adam and Eve in the instant of assigning names in the Garden of Eden. The Symbolic act also leaves behind an unsignified residue of the Real that, ever after, haunts the subject with the ghostly being of the nameless Thing.

Holbein's anamorphosis of the skull provided the cover illustration of *Book XI* of Lacan's 1964 *Seminar* when it was published in 1973, but already here in *Book VII* we can see at work the fundamental split that Lacan later elaborated between the eye and the gaze. Transfixed by the mesmerising illusionism of Holbein's art, the frontally aligned eye of the spectator complacently surveys a world made in its own image, with its bodily likeness and creaturely comforts temptingly displayed as if to the mythic Narcissus in his first moments at the mirror or the modern subject upon the mirror stage of illusory self-love. Like the psychoanalyst who sits outside the line of sight of the patient the better to attend to the Symbolic meanings of his or her discourse rather than be caught in the Imaginary face-off of admiration, rivalry and pretense, so too the spectator at the side of the painting may accede to the Symbolic level of interpretation by looking obliquely past the blurred images of worldly wealth in order to bring into

focus the empty eye sockets of the skull, the blind gaze of death. Lacan called this perspectival anamorphosis the painting's sinister truth, the signifier of the subject's death. This sidelong image of the skull cannot simultaneously be held in focus along with its frontal appearance as an amorphous stain. And yet, Lacan insisted, we get pleasure as we repeatedly reposition ourselves from the front to the side and savour the oscillating appearance and disappearance of an illusory image from out of a nothingness to which it returns. Like the child with its teddy bear, comfort blanket or thumb, we gain an Imaginary mastery over the unavoidable contingency of life by playing with a Symbolic representation of the cranial bone of death.

This emergent anamorphic thing of the skull is not in itself the Thing. The Thing itself always remains inaccessible, but with the aid of the signifying trait of language that first severed us from the primordial Thing we can at least point to its withdrawal from us. Thus the definition of sublimation: 'A work of art always involves encircling the Thing.' Encircling the Thing, yes, but only from the safety of aesthetic distance. Lacan affirmed that the aim of artistic representation was not to become an object of realistic imitation. The work of art was not realist but other than realist, and through its deployment of the signifying elements of art it represented the Thing in its illusory presence and actual absence at one and the same time. To come too close to the Thing of our fundamental fantasy would endanger the very stability of our identity as a named individual. Lacan himself may have manifested anxiety about the unspeakable Thing he was endeavouring to speak about by mistakenly placing Holbein's painting in the collection of the Louvre rather than in its proper place at the National Gallery in London.

The uncanny duality of showing and hiding in Holbein's anamorphic skull may be compared to a notorious Dadaist object of 1920, *The Enigma of Isadore Ducasse*, by the American artist Man Ray, in which an unseen sewing machine is wrapped in a

blanket (Tate Gallery, London). More recently, something of the uncanny hiddenness of the Thing has been made manifest at the centre of our cities in the widely publicised projects of the Bulgarian and French team of married artists Christo and Jeanne-Claude, such as the *Wrapped Pont-Neuf* in 1985 in Paris or the *Wrapped Reichstag* in 1995 in Berlin.

In his lectures on the ethics of psychoanalysis, Lacan turned to works of art in order to exemplify his thesis on the sublimation of the disturbing fleshly allure of Imaginary maternal presence in the pacifying formal structures of Symbolic paternal inference. Echoing the evocation by the French writer Paul Claudel of the transcendent dignity of the ordinary objects depicted in Dutch seventeenth-century still life paintings, Lacan asserted the special status of this genre of *nature morte* ('dead nature', in French). For Lacan, these paintings of still life vibrated between the everyday utilitarianism of the depicted objects and an extraordinary mirage of beauty that seemed to stop the flow of time in which those objects would normally be consumed. In a 1936 essay on the origin of the work of art, Heidegger had found a transcendent dignity of the object in the still life paintings of shoes by the Dutchman Van Gogh. In his own discussion of Van Gogh's *Shoes* (1886, Van Gogh Museum, Amsterdam), Lacan again stressed art's poised equidistance between the mundane reproduction of objects of ready use and the arbitrary creation of a signifying order that resisted useful appropriation in the name of the sheer uselessness of beauty. In its negation of the accident of life painted beauty wears the absolute mask of death, the sublimated representation of the transcendent dignity of even the merest empty shoe.

In his remarks on *nature morte* Lacan silently turned to a 1945 essay by his friend, the philosopher Merleau-Ponty, on the art of the French painter Paul Cézanne. For Lacan, Cézanne's still life of *Apples* (1878, Fitzwilliam Museum, Cambridge) succeeds as art precisely by failing to appear as the convincing imitation of edible

pieces of fruit according to the reigning pictorial conventions of his age. In indicating the formal mechanism by which the illusion of Cézanne's *Apples* was both accomplished and at the same time undone, Lacan touched on the shifting history of art as well as what he considered to be its enduring transhistorical mystery. On the one hand, Cézanne's efforts were to be understood in a relation of subjective opposition to the conventional work of his financially successful counterparts. On the other hand, Cézanne's art was also to be seen as manifesting a relation of objective indebtedness to the Symbolic order of the signifier as such. Through a novel manipulation of the formal properties of the Symbolic language of art, some outstanding members of earlier generations of artists had also attempted to renew the dignity of the Thing that had become compromised by overexposure and routine use. In his *Apples* Cézanne endeavoured to raise an ordinary, visible, Imaginary thing to the Symbolic level of the extraordinary, invisible Thing. Cézanne's painting would thus have been both a showing of the lost materiality of the maternal Thing and its hiding beneath the paternal veil of artistic language.

According to Freud's scenario of sublimation, the artist gained satisfaction without the pain of neurotic repression by transforming the maternal object of paternal interdiction into a work of art. The successful artist was rewarded with fame and money by a grateful public that unconsciously recognised in the artist's works the traces of its own censored dreams and desires. Lacan argued that this account of the commercial valorisation of art was merely a short-circuiting of the problem of beauty, about which Freud had often conceded that he had nothing of value to say. Lacan was not similarly reticent on the subject, proposing that the creation of the effect of beauty in art succeeded by disarming the darts of desire. Duchamp's 1951 *Objet-Dard* (*Object-Dart*, *Object of Art*) simultaneously offers the viewer the exterior form of the penis and the interior mold of the vagina while being neither

the one nor the other but, rather, their impossible co-relation in the Symbolic form of art.

The beautiful appearance of the work of art damps the fires of unfulfilled desires, but this is a beauty that may not be touched. Look all you like but don't touch the art object, the sign in the museum says. To this admonition regarding the proper enjoyment of artistic property the psychoanalyst adds that it behooves us to maintain a safe distance for our own sake, all the while keeping the object of our desire directly in our sights. In this erotic tango of distance and proximity we find the elements of the formula of fantasy, the split subject of the unconscious steadfastly facing the object's swirling hypnotic void – $<>@. One might think here of Duchamp's breast-like mechanical *Rotary Demisphere* of 1925 or the equally hypnotic metronome of Man Ray's eye-emblazoned *Indestructible Object* of 1923 (both Museum of Modern Art, New York).

Carried along in the unending stream of signifiers, unassuaged desire splits the subject of spoken language into conscious and unconscious constituencies. Although not sanctioned by Lacan's own typographical practice, I believe that this split subject is appropriately designated throughout this text by the dollar sign – $ – inasmuch as it is the global flow of capital that constitutes us as conscious and unconscious consumers within the worldwide store of commodities on which our modern subjecthood of lack so largely depends. Objecthood for us resides in the empty form of the commodity itself – <> – for beyond it lies the unattainable object of the endlessly circling corporeal drive, designated by the typographical sign for both an individual item's price – @ – as well as a named individual's concrete e-mail link to the disembodied web of commercial cyberspace. Barbara Kruger, an American graphic artist who escaped from the consumerist world of advertising, challenges us with a huge photograph of an empty hand seeming to hold a sign that declares, 'I shop therefore I am' (1987).

In the dollar sign the subject of the desired commodity is cleft in twain, making it an alienated Symbolic object – $ – to itself. Into the empty frame of the commodity is projected the Imaginary object – <> – that is desired just because it is that which the other is presumed to desire from among the ever-changing high-gloss and hard-sell images of the mass media. And in its repetitive circling of the Real Thing – @ – as a popular cola calls itself, the corporeal drive pays again and again the price of its mad roulette wager to recover the original stake it has irreversibly lost. In the face of the unrelenting demand of the Other – $<>D – for me to be Its lost object, I fashion for myself a fantasy – $<>@ – in order to protect myself from being drawn into the Other's lethal grip. In the variegated forms of artistic sublimation I retrieve some abject scrap of materiality, which is all that remains from the primal severing of the voice, gaze and flesh of the Thing. Subject, object, abject. Symbolic, Imaginary, Real. $<>@.

Chapter 4

The lost object

Book eight of Lacan's seminar transcribes his lectures on the topic of transference. As understood by Lacan, transference describes the patient's wishful, though erroneous, endowment of the analyst with a presumption of the knowledge that will provide relief from her or his suffering. Also projected upon the person of the analyst are feelings of love and hate derived from the patient's most intimate relations with parents, teachers, colleagues, friends, siblings, children, lovers. In refusing to gratify the demands of the patient for reciprocal declarations of love, direct answers to questions, even normal conversation between social peers, the analyst requires a high degree of libidinal sublimation from the analysand in order to allow repressed signifiers to emerge and the fundamental fantasy to be freed. Rather than the dyadic other of the Imaginary partner of the mirror stage or the triadic Other of the impersonal Symbolic code, the analyst must position himself or herself in relation to yet another other. This other is the same for everyone regardless of familial or cultural situation; this other is the monadic or absolute other of the Real. This is the One other that was lost to each and every human subject upon its traumatic entry into the world of articulated demands and unsatisfied desires and around which the drive continuously turns. It is because of this invariable One that Lacanian psychoanalysis is neither historicist nor relativist with respect to the lost animal embodiment of every woman and man.

Irrevocably severed from its animal being as a result of the Imaginary and Symbolic failure to represent it fully in either image

or word, the subject can signify the Thing only in its absence from the repertory of representation. Symbolic castration is the consequence of this absence of immediate animal presence in our mediated forms of representation; and the signifier of this absence is the Symbolic phallus. This phallus is not the symbol of any existing entity of flesh, such as a particular man's penis, but is, rather, the Lacanian name for the substitution of a present word for an absent thing in the creative act of signification. This phallus occupies the empty space of disembodiment that the signifier carves out of the Real. In short, the popular conception of the Freudian phallus of paternal potency and power is a fallacy, a fraud.

Castration

Lacan brought to his lectures on castration a reproduction of *Psyche Surprising Cupid* by the little-known Italian painter Jacopo Zucchi, which the psychoanalyst had recently seen in the Borghese Gallery in Rome (1589; Figure 5). He also exhibited a sketch of the painting made expressly for the seminar by his brother-in-law, André Masson. Masson had similarly provided Lacan with an updated version of a painting by the Frenchman Gustave Courbet entitled *The Origin of the World* (1866; Figure 6), which several years earlier Lacan had acquired for his private collection. Serving as a sliding cover to hide an object to be seen only with discreet precaution, Masson's brushstrokes shrouded in snowscape-like outlines the contours of the shockingly naked female body beneath. As framed by the realist painter Courbet and reframed by the surrealist painter Masson, this was a close-up view of a reclining woman whose body was cut off at the thighs and shoulders by the picture's bottom and top edges and whose opened legs revealed her genitals, her belly and her partially covered breasts. Given to the French state by Lacan's heirs in lieu of taxes on his estate, the painting now flaunts itself at the Orsay Museum in Paris as the most celebrated image of the Lacanian maternal

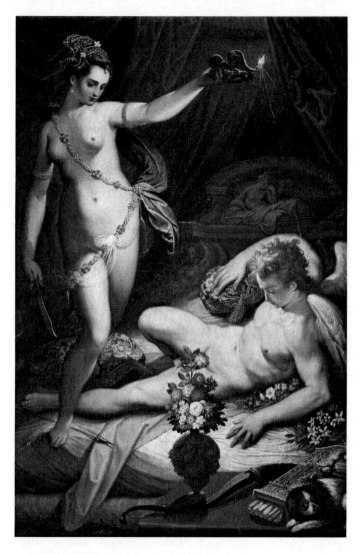

5. Jacopo Zucchi, *Psyche Surprising Cupid*
(1589).

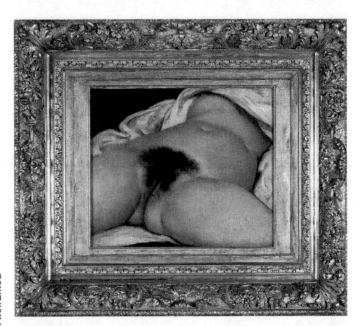

6. Gustave
Courbet, *The
Origin of the
World* (1866).

Thing. In the vulgar pun of *Lacan/la
con*, Courbet's picture of the Imaginary
female phallus becomes a Symbolic allegory
of the analyst's name. It provides the
unsuspected private backdrop for Lacan's
public remarks on Zucchi's painting of Cupid
and Psyche, an ancient erotic narrative that
also figured among the semi-pornographic
nudes of Courbet.

In Zucchi's painting we see the nearly nude
figure of Psyche, a drawn dagger in her right
hand, and a lamp held high in her left hand to
illuminate the sleeping figure on the bed at
her feet. This is Cupid, son of Venus, the
goddess of love, who had made love to the

mortal woman Psyche under the cover of darkness and who had forbidden her from seeking to gaze upon his face. Her nascent pregnancy covered by the merest veil of diaphanous drapery, Psyche appears to be looking directly down at the penis of Cupid, which the painter has hidden from the spectator's view by placing in front of it a large bouquet of flowers in a vase. As in Holbein's *Ambassadors,* with its conflicting perspectives of Imaginary life and Symbolic death, here we have the split between Psyche's eyeful of the impregnating member of her divine lover and the gaze of the bouquet that keeps us from seeing what we would like to see. If the Real penis of insemination appears only in the absent form of the Symbolic phallus of castration, this severing is sutured together by the reassuring fetish of the Imaginary maternal phallus in the erect figure of Psyche herself. The figure of Psyche is the traditional symbol of the Soul seeking to face the mystery of corporeal Love to which it is driven despite the prohibition of the Law. Psyche is also a personification of psychoanalysis itself, which in Freud's compound German phrase of *Psycho-Analyse* would be better translated as 'Analysis of the Soul'.

In the title of *Psyche Surprising Cupid,* Lacan's listeners may have heard an allegory of the psychoanalytic technique of free association, whereby the analyst listens to the analysand's spoken discourse in order to surprise the signifiers of unconscious desire in the unpredictable instant of their emergence from the fetters of repression. Zucchi's painting is yet another example of the dialectic between the eye and the gaze, between the visible and the invisible, between the body and the soul, between the Imaginary register of immediate perception and the Symbolic register of mediated conception. Fearing that her lover and the father of her unborn child might be a hideous monster, Psyche looks between the legs of Cupid in a desire for carnal knowledge. Equally desirous for knowledge, the spectator finds in that place of would-be certainty that there is precisely nothing to see, no

meaningful word to say. Referring in his essay 'The signification of the phallus' (1958) to a mural painting of a shrouded sculptural phallus in the Villa of the Mysteries at Pompeii (50 BCE), Lacan insisted that the phallus plays its Symbolic role in society only when it is veiled. Only as veiled is the phallus the signifier of its own absence, its own castration.

The anxiety of Imaginary castration arises from the rivalry of the egos of the mirror stage, between oneself as alter Ego and the image of the ideal Ego of the m/other. In Zucchi's painting a direct expression of this fear would have been to depict Psyche cutting off the penis of Cupid with her dagger. Symbolic castration represents the overcoming of the anxiety of Imaginary mutilation by enabling the subject to separate itself from the intimate impasse with the m/other by way of an identification with the public signifier of the paternal Ego-ideal. Zucchi may have been locked in personal rivalry with any number of contemporaries, but he also had the chance to become an artist with an independent style, because the theme of Cupid and Psyche was freely available in his cultural tradition for formal elaboration and reinvention.

We should understand Symbolic castration as nothing other than the gaping cut between what we directly see and what we indirectly say we see by means of the signifier. For Lacan, the Real corporeal penis offered itself up for transformation into the disembodied Symbolic phallus insofar as its rhythm of tumescence and detumescence, of appearance and disappearance in copulation, mimes the filling and emptying of the signifying void that it is the task of the signifier to accomplish. In his analysis of Zucchi's painting, Lacan insisted that the bouquet of flowers was not painted over a pre-existent representation of the penis of Cupid but, rather, provided a veil behind which there was no actual penis to see but only the void of the name of the Symbolic phallus to say. Following a fundamental premise of Freud, Lacan affirmed that the sublimation of animal nature into human culture was best exemplified by the supplementation of the perceptually evident

connection of the mother and her child at birth with the abstract inference of paternity and the attribution to the child of the father's Symbolic name.

Borrowed from the dictionary of the Other, the signifier confers upon the emergent subject the power of naming its needs in the form of demands addressed to other subjects, beginning with the primary caregiver, who is most often the mother. At the same time, however, the signifier cuts into the subject's experience of un-divided mother-child embodiment, leaving behind the scar of that severed pound or ounce or shred of flesh that goes under the name of the lost object. This object of primal loss remains an object of desire only as long as it is not possessed, for it becomes an object of anxiety if it is felt to get too close.

In *Book X* of *The Seminar*, on the topic of anxiety, Lacan illustrated his concept of the object from which the subject must learn to separate itself by appealing to old master paintings he had recently seen. These were a pair of paintings by the Spaniard Francisco de Zurbarán, whose standing, half-life-sized representations of Saint Agatha (1633, Fine Arts Museum, Chartres) and Saint Lucy (1636, Fabre Museum, Montpellier) show them calmly displaying the cut-off body parts of their torture and martyrdom to the beholder's gaze. Richly dressed in red, yellow and black against a bare, shadowy ground, Saint Lucy appears to cast her heavily lidded gaze down at her exorbited eyes lying upon a platter she holds at her waist. Similarly attired, Saint Agatha turns her gaze outward as if to offer the spectator her two severed breasts on a plate as objects of carnal sacrifice. In these separated body parts Lacan saw the Imaginary envisioning of the abject remainder of the Real, the uncanny object that was left behind as an irretrievable residue of flesh upon the subject's entry into the fleshless realm of the Symbolic signifier. The formula of fantasy – $\$<>@$ – captures the precarious sublimation whereby the alienated subject of linguistic signification must endeavour to hold in check the primordial anxiety of corporeal mutilation that

clings to the appearance of the severed object. Castration anxiety is merely a secondary mask that prevents the subject from having to face its still more archaic severing from the mother's placenta, breast, voice and gaze.

In Western art, the mutilation of the male body is repeatedly staged in scenes from Cain killing Abel in the book of Genesis to the Gospel accounts of the flagellation and crucifixion of Christ. Powerful women are perpetrators of this violence in Biblical paintings by the Dutch master Rembrandt of Delilah cutting off the hair of Samson (1636, Städelsches Kunstinstitut, Frankfurt) and of Judith beheading the Assyrian general Holofernes (1599, Palazzo Barberini, Rome) by the Italian master Michelangelo da Caravaggio. In an autobiographical version of the latter subject, the painter Cristofano Allori is thought to have depicted his own features in the decapitated head that is held in the grip of his mistress who modelled for the female hero (1613, Palazzo Pitti, Florence). The tables are turned in a representation of the same subject by Allori's female contemporary Artemisia Gentileschi, who by means of the fictive scenario of her painting may be taking revenge on a male artist who had assaulted her and on account of which she had endured public trial and torture (1620, Uffizi Gallery, Florence). The equally popular subject of Salome carrying the severed head of John the Baptist on a platter provided the British artist Aubrey Beardsley an occasion to relish the perverse fantasy of masculine humiliation at the hands of the femme fatale in his controversial illustrations of Oscar Wilde's notorious play of 1894.

The traumatic cut of separation became a matter of personal rather than art-historical concern to Lacan in late 1963, when his colleagues in the French Society of Psychoanalysis acquiesced to a demand of the International Psychoanalytical Association that he be formally separated from their group. They were required to cut Lacan from the ranks of their training analysts in order to enjoy all the prerogatives of institutional membership. By this time

Lacan had been promoting his controversial views in his public seminar for more than a decade, but it was his heterodox practice of varying the duration of his clinical sessions with patients that precipitated the definitive break with the international organisation. Lacan maintained that varying the duration of the session enabled the analyst to punctuate the discourse of the patient at whatever point repressed signifiers seemed to break free from the patient's resistance, but the international governing body held that the practice violated the patient's legitimate expectation to have the analyst fully available for the entirety of the hour. At the lone seminar on the Names-of-the-Father in November 1963, his last held at the hospital of Sainte Anne, where he had been teaching since 1953, Lacan likened his institutional fate to the excommunication from the Jewish community of the seventeenth-century philosopher Baruch Spinoza.

Lacan had long identified with Spinoza's dictum that desire is the essence of man. In the philosopher's acknowledgement of the intellect of God in every parcel of matter in the universe, Lacan recognised the universality of the signifying cut of the word, whereby the world's materiality took on meaning for man. Lacan exemplified this idea of the shattering, world-creating power of the word with the Biblical story in which the Jewish patriarch Abraham made ready to sacrifice his son Isaac on the authority of nothing other than the word of an invisible God with an unpronounceable Name. As depicted by Caravaggio around the year 1600 (Uffizi Gallery, Florence), the bald and bearded father, his heavily draped figure cut off at the knees by the painting's lower edge, holds down the head of his bound and naked son upon a stone altar with his left hand while his right hand grips the sacrificial knife at the centre of the painting. This hand, in turn, is held in check by the right-handed grasp of a naked winged angel, cut off by the frame on the left, who points with his left index finger across the span of the composition to a ram, cut off by the frame at the right, that will be the sacrificial substitute for the

son in accordance with God's word. The pointing finger, the drawn blade, the ram, and the cut-off figures of the angel, the father and the son are all so many embodiments of the cut of the signifier itself by which the world's random array of visible matter is sublimated into the Symbolic representation of an idea. It was on account of this abstract idea of Symbolic separation that a particular family trio – Abraham, Isaac and his mother Sarah – cut itself off from its extended kin – Abraham's concubine Hagar and her son Ishmael, forefather of the Arabs – in order to take on the new name of the Jewish nation. This Symbolic split within a single family tragically reverberates today in the Middle East and around the globe.

In Caravaggio's composition, the Imaginary configuration is transfigured by a Symbolic name beyond which lies the nameless anxiety of the Real. The remnant of the Real is the foreskin of the penis, the abject piece of flesh cut off by the signifying blade in the identity-conferring rite of circumcision that Abraham and Isaac passed down to their male descendants. The ritual act of circumcision provided the Imaginary basis for Lacan's doctrine of Symbolic castration. In the accession to cultural identity by way of Symbolic identification with a community's arbitrary signifier, a piece of the Real of universal embodiment is sacrificed. Here again we find our formula of sublimation: the split subject of the signifier facing the lost remnant of its primordial embodiment from across the empty frame that is provisionally filled out by the work of art – $\$<>@$. In the sacrifice of Isaac the lost jouissance of the flesh became the Symbolic essence of the Jew.

Chapter 5

What is a picture?

'Excommunication' is the title of the opening chapter of the first of Lacan's annual *Seminars* to be published, the first seminar not held at the psychiatric hospital of Sainte Anne as a pedagogical program of the French Psychoanalytic Society, and the first held under university auspices at the prestigious Ecole Normale Supérieure. Initially announced under the title *The Foundations of Psychoanalysis*, the seminar was summarised by Lacan in 1965 under the fourfold rubric of the unconscious, the repetition compulsion, the transference and the drive. TURD (transference–unconscious–repetition–drive) strikes me as an appropriate device for the recall of Lacan's four fundamental concepts, especially in view of the new stress in this seminar on the so-called object 'a'. Object 'a' designates the lost object as an abject remnant and uncanny revenant of the Real. Its lower-case 'a' stands for *autre* or little other in order to distinguish it from the Big Other of the general language system. In French *objet a* was pronounced by Lacan as *objet petit a*, 'object small a', both in order to preserve its quasi-algebraic character as an abstract symbol for the absence of the lost object and also to sound like *objet petit tas*, 'a little pile of shit'. In 2007 broadsheet manifestos on behalf of the unmediated actualisation of desire were pasted on top of New York City street art murals with the title 'Art: The Excrement of Action'. Reduced to the status of a commodity, the *objet d'art*, the object of art, is the objective turd of the artist's lost labour of love.

Published as *The Four Fundamental Concepts of Psychoanalysis*, the chapter headings and sectional notations of *Book XI* of *The Seminar* are the artefact of Jacques-Alain Miller's editorial punctuation of his father-in-law's spoken discourse that a stenographer had more or less accurately transcribed on the spot. The result may be as much Millerian as Lacanian, an interposed filter between the lost voice of the analyst and the dead letter of the disciple's written law. Coming seven years after the publication of *Ecrits* in 1966, the 1973 publication consolidated Lacan's reputation in French intellectual circles, just as the translation of these same two volumes did for English readers in 1977. *The Four Fundamental Concepts of Psychoanalysis* expanded the exposure of Lacan's doctrine to university audiences in literature and philosophy but did little to alter the disapprobation of Lacan's technical dissidence and theoretical difficulty for the membership of British and North American psychoanalytic societies. Despite what Lacan called his embarrassment where art was concerned in the 1976 preface to the English translation, the widespread attention on the part of artists and critics to the four lectures entitled 'The split between the eye and the gaze', 'Anamorphosis', 'The line and light' and 'What is a picture?' has made a reading of *Book XI* of *The Seminar* an indispensable component in understanding the culture and commentary of the visual arts over the course of the past twenty-five years. Three internationally prominent artists who have called upon Lacanian theory in their writings, images and installations are the English Victor Burgin, the American Mary Kelly and the Israeli Bracha L. Ettinger.

The split between the eye and the gaze

A chance impetus behind Lacan's lecture on the split between the eye and the gaze was the posthumous publication in 1964 of the fragmentary manuscript *The Visible and the Invisible* by Merleau-Ponty. In an obituary tribute written at the time of his friend's early death in 1961 at the age of fifty-three, Lacan had remarked

on the phenomenologist's tentative strivings beyond the visibility of the eye of perception into the invisible domain of the gaze of signification that seemed to him to abut his own efforts in psychoanalysis. In Cézanne's little blue and brown brushstrokes, already the subject of Lacan's commentary in *Book VII* on sublimation, Merleau-Ponty had perhaps begun to see a signifier-like character whereby the painter laboured, as he himself wrote, to make his works speak. For Lacan, this was a fundamental instance of the split in the experience of the speaking subject between the Imaginary eye of conscious visual perception and the Symbolic gaze of meaning mediated by the invisible network of signifiers through which the work of visual art was made and viewed. Just like the vacillating position of the subject of unconscious desire in language, Cézanne's position as the subject of unconscious desire in painting was suspended in the blank intervals between one and another signifying touch of paint. It was in this sense that Lacan argued that, unlike a sign that represents something for someone according to the classic definition of the American philosopher Charles Sanders Peirce, a signifier represents the subject for another signifier. As disclosed by Lacanian psychoanalysis, the inscription of Cézanne's subjectivity was precisely nowhere to be found other than in his little pats of paint.

Following Merleau-Ponty's lead, Lacan insisted on the pre-existence of the overall field of visibility to the agency of any individual eye looking at the world. Whereas the individual sees from one specific point in space, that same individual is susceptible to being seen on all sides. For the psychoanalyst, however, this was not simply a question of the corporeal limits of vision. In its exposure to the invisible gaze of others, the subject discovers itself as prey to the discomposure and objectification that Lacan saw as the equivalent of castration anxiety in the visual field. It was in this split between the subject's seeing eye and the subject's exposure to the other's gaze that Lacan situated the

reflexivity of the scopic drive. Also known as scopophilia, the libidinal drive of the look is not only to see the object of desire (voyeurism) but also to make oneself seen by the other as the desired object of its gaze (exhibitionism). The subject is in part produced as the invisible lost object of the m/other's gaze that the scopic drive insistently demands to recover but can only revolve around its absent place. This is why I use the typographical symbol @ to mimic the circular revolution of the drive around the void of the lost object. The subject in its role as the m/other's lost object is one of the primary forms of the object 'a'.

On the level of the Imaginary this is the familiar scenario of the *Mona Lisa,* where the artist repositioned himself in unconscious fantasy to become once again the lost object of his mother's childhood gaze. We can extend that scenario to include the desire to be gazed at on the part of the woman of the portrait herself. Here Lacan saw the satisfaction of a beautiful woman who knows that she is being observed, who does not show that she knows, and whose observers do not show that they know that she knows. Basing his views on an essay of 1929 by the English psychoanalyst Joan Riviere, 'Womanliness as a masquerade', Lacan regarded the woman's beautiful appearance as an aesthetic strategy of sublimation whereby she transformed herself through cosmetics and fashion from a flesh and blood creature in the Imaginary order of visible things into an abstract, impersonal, Symbolic ideal. In the paradoxical presence of her masquerade she made apparent the absence of the Real Thing.

The illusion of autonomous agency of the 'I see' of the Ego corresponded for Lacan to the Imaginary self-deception of the famous 'I think' of the French seventeenth-century philosopher René Descartes. Expressing the desire for certain human knowledge, the philosophical theorem 'I think therefore I am' (in Latin, *Cogito ergo sum*) was to be replaced by Lacan's psychoanalytic axiom of the uncertainty of human desire, *Desidero ergo sum*, 'I desire therefore I am'. On account of the lost object

I am a creature of lack. On account of my lack I am a creature of desire. And because the acquisition of any particular thing I see can never be more than a meagre substitute for the lost desire of the m/other, the persistent desire for something other remains my permanent condition.

In the tragic split insisted on by Lacan, the eye was on the side of the Imaginary Cartesian delusion of subjective agency – I see – and the gaze was on the side of the Real object of anxiety – I am seen, I am shown – caused by the subject's double exposure to the enigmatic desire of the Imaginary m/other and the Symbolic Other: 'What the hell does She/He/They want with me?' In the consciousness of waking life I may imagine that I initiate the seeing of what I see, but in the unconsciousness of sleep it becomes apparent that I do not actively see but, rather, am passively shown the dream scenario in which I am put on display. This coercive showing to the dreamer of the gaze of the dream is similar to the posture in which the spectator stands in front of the vacillating op art of the 1960s by the Hungarian-born French artist Victor Vasarely or the English painter Bridget Riley.

Anamorphosis

The uncanny visibility of Symbolic castration in painting was the subject of Lacan's lecture on the visual distortion of anamorphosis. Here Lacan returned to his earlier meditation on Holbein's anamorphic skull by way of the recent eulogy of Merleau-Ponty. In Lacan's return to the subject of death he was re-enacting the repetition compulsion itself, one of the four fundamental concepts of psychoanalysis that it was his concern to expound. In the original topography of the drives of around 1900 Freud had postulated a fundamental conflict between the self-preservative and sexual drives, but with his development of the theory of narcissism around 1910 the Ego itself was discovered to be not only the source of sexual interest in others but also the recurrent object of auto-erotic sexual regard. In working with the recurrent

nightmares of surviving soldiers of World War I, Freud began to formulate the notion of a repetitive drive in which individuals seemed to prefer to revisit past situations of pain rather than to seek new avenues of pleasure. In *Beyond the Pleasure Principle* of 1920, Freud launched his second topography of the subject in which the interpersonal intercourse of the erotic drive was said to be in continuous conflict with the destructiveness and self-destructiveness of the death drive. The majority of Freud's followers in Ego psychology failed to follow their master's speculations in this lethal direction, but Melanie Klein saw the outward projection of the death drive in children's aggressive fantasies of dismemberment of the mother's body – a dismemberment that could be repaired in the sublimated formal unity of the work of art.

In his early paper on the mirror stage written in 1936 and revised in 1949, Lacan also saw the death drive at work within the subject in the violent disparity that the young child experienced between the uncoordinated and fragmentary movements of the parts of its body and the seamless unity of the image that confronted it in the mirror. In that widely read essay (included as the opening chapter in the selected translation of *Ecrits* in 1977), Lacan exemplified the fantasy of the fragmented body by appealing to the visionary works of the Netherlandish master Hieronymous Bosch, who depicted around the year 1500 the tortured limbs and distended organs of the persecuted souls in Hell in *The Garden of Earthly Delights* (Prado Museum, Madrid). In 1964 this blatant Imaginary fantasy of the body-in-pieces was replaced with the latent image of Symbolic castration of Holbein's anamorphic skull that remained invisible when viewed in the frontal manner of Merleau-Ponty's phenomenology of perception. Nevertheless, the philosopher's posthumous pages on the emergence of the individual seeing eye from the primordial flesh of the world evoked a tantalising glimpse of the amorphous space of the Real that invisibly undergirded the articulation of the unconscious.

Nonetheless, Lacan maintained that Merleau-Ponty did not adequately acknowledge the death drive of the Symbolic order whereby the continuity of the Real was broken down by the discontinuity of the signifier into that which could be articulated and the remainder that could not. The breakdown of the myth of corporeal unity upon which phenomenology depends is aptly illustrated in René Magritte's *Eternal Evidence* of 1930 (Menil Collection, Houston), a series of five vertically hung paintings of fragments of a woman's naked body from head to toe.

Because I can never look at myself from the position of my mother's gaze I take what satisfaction I can by looking at myself in the mirror instead. For Lacan, this narcissistic satisfaction in seeing oneself seeing oneself was a defensive effort aimed at eluding the objectifying consequences of the outside gaze. When, as an artist, I look in the mirror to paint my self-portrait I see myself seeing myself, but what I do not see is the invisible gaze of the Other to which I unconsciously show myself in order to be acknowledged as worthy of recognition. Firstly, at the level of the Imaginary, the other, the little other, is someone like me, my ideal Ego, on the pattern of which I fashion myself as alter Ego. Secondly, at the level of the Symbolic, the Other, the Big Other, is the communal storehouse of signifiers from which my mother and father selected a name before my birth and a set of descriptions thereafter that circumscribed me as the anxious object of their enigmatic desire. Thirdly, at the level of the Real, the other, the lost object or object 'a', is the fallen fleshly part of me from which I was severed upon my forced entry into the Symbolic order of speech. Previously Lacan had stressed that this lost object was an object of desire that could be aimed at by putting an image or a name in the place of the desired Thing. Now Lacan insisted that the object 'a' was visually unimaginable and literally indescribable, but should be understood instead as the irrecuperable object around which the libidinal drive incessantly turned. The desire to recover the lost object 'a' is impossible to satisfy, but this impasse is

circumvented in the working of the drive. The drive finds its satisfaction not in the ultimate attainment of some final goal, but in the unending process of seeking itself.

The lost object 'a' of the oral drive is the weaned, rejected breast that once constituted a part of the joint flesh of the mother-child dyad that the speaking subject may later grieve as lost even though it doesn't truly want it back. Similarly, the lost object 'a' of the anal drive that one doesn't want back is the bowel movement offered as an appeasing gift in response to the m/other's toileting demand. Freud and Klein had written extensively of the oral and anal drives and their corresponding objects, but Lacan introduced two additional drives as related less to the imperative of the m/other's demand and more to the enigma of the m/other's desire. The lost object 'a' of the invocatory drive is the sound of the m/other's voice prior to its decipherment by the subject as a signifying word. And the lost object 'a' of the scopic drive, the object of Lacan's closest attention in *Book XI*, is the reciprocal gaze of the mother and child, the vanishing of which constituted me as a mutilated eye in my I's exile from the Real. Previously, in *Book VII*, sublimation was seen to offer the Symbolic subject of desire in language the cultural opportunity to position itself by means of the Imaginary semblance of the work in a face-to-face relationship of fantasy to the lost object of desire – \$<>@. Now, in *Book XI*, the subject was invited to cross the plane of the fantasy – <> – and separate itself from the alienation of its Symbolic identification – \$ – in order to experience the jouissance of the drive in its repetitive encirclement of the object 'a' – @ – as a lost remnant of the Real. And what does the drive encircle? It encircles the void of the subject itself. We see this endless spinning around an emptiness in the first of Duchamp's famous ready-mades, the spinning *Bicycle Wheel* of 1913, the original of which is appropriately lost (1951 replica, Museum of Modern Art, New York).

The mask

Within the circuit of the scopic drive the lost remnant of my primordial separation from the mother is the gaze. Painters, Lacan claimed, have managed to recapture something of the pre-Symbolic blankness of that gaze in what he called the mask, as, for example, in *The Maja and the Masked Men* (1777, Prado Museum, Madrid) by the Spanish master Francisco de Goya. Another artist remarked by Lacan who played extensively with the mask and the gaze is the Belgian painter James Ensor in his *Self-portrait with Masks* (1899, private collection).

In *Book VIII* of *The Seminar*, Lacan discussed the function of the mask in relation to the work of the Italian painter Giuseppe Arcimboldo. It was Arcimboldo's unusual conceit to create the illusion of a human face by means of the artful arrangement of inhuman elements such as fruits, flowers, or, in the example cited by Lacan, books, as in a 1566 portrait of a librarian (Skokloster Castle, Sweden). What was at stake in a portrait was not the visual trickery of painting an Imaginary semblance of a human being but, rather, the frank declaration of the artifice of its Symbolic identity as a subject of the Other's enigmatically masked desire. So why do I don the Symbolic disguise of my social persona, Latin for 'mask'? In order to fend off the suspicion that beneath the mask there is in fact nothing of substance to see. Claude Cahun, a member of Lacan's surrealist social circle of the 1930s, has recently achieved posthumous acclaim for her self-portrait photographs, in which she often appears masked: 'Under this mask, another mask. I will never be finished removing all these faces.'

Lacan coupled his references to Arcimboldo in *Books VIII* and *XI* with references to the art of Salvador Dalí, his long-time friend and fellow agent provocateur. In his autobiography, *The Secret Life of Salvador Dalí* (1942), the painter reported that at their first meeting in Paris he and Lacan were astounded at the congruence of their views on the primacy of paranoia as a form of active

psychological invention, contrary to the passive experience of the dream that previously had provided the paradigm for the surrealist appropriation of the Freudian theory of the unconscious. Back-to-back articles by Lacan and Dalí in 1933 in the journal *Minotaure* articulated the intersection between the research on paranoia of the psychiatrist and the self-styled paranoiac-critical method of the painter. Whereas Lacan insisted on the systematic meaningfulness of the delusions and hallucinations of clinical paranoia that orthodox psychiatry still judged to be meaningless, Dalí projected his hallucination-like surrealist visions onto the perspectival coordinates of traditional realism. Under the pressure of unconscious desire the realist vision of the eye was transformed into the surrealist haunting of the gaze.

According to Lacan, the suffering subject of paranoid psychosis lacked a stable signifier of the father with which to fashion a normative social identity. In consequence of this deficit, the paranoid subject experienced the world at large as centring its overwhelming gaze on him or her as the unwilling object of incestuous desire, maternal engulfment, or paternal castration. It was Lacan's clinical finding that the paranoid subject unconsciously preferred to be the object of an Imaginary persecutory gaze rather than to be unseen and disregarded within the intimate matrix of the family. Dalí insisted that the difference between himself and the paranoid psychotic was that he was not mad. His hallucinatory paintings were not delusional but, rather, a lucid critique of the conventional perception of realism in art as a geometrical matter of perspectival illusion. After meeting Dalí in London in 1938, Freud wrote that, whereas in the works of the old masters he sought the hidden note of the unconscious, in Dalí's art it was the conscious intention that he saw. In drawing the dying Freud's head according to his method of simulated delusion Dalí depicted a human skull with the involuted form of the shell of a snail (1939–41, Dalí Theatre-Museum, Figueres, Spain).

In Lacan and Dalí the optical regularity of perspectival projection was displaced by the paranoid distortions of anamorphosis. Looking at the amorphous blot of Holbein's skull through surrealist eyes, Lacan saw in the unrecognisable shape the profile of the masculine erectile organ. He later noted Leonardo's recommendation, in *Book XIX* of his *Seminar*, that artists should look for figures hidden amidst the shapeless stains of old masonry walls. Beyond Lacan's mock-paranoiac finding of the Imaginary phallus in Holbein's stain Lacan also pointed to its Symbolic disappearance as the signifier of castration. Now it surges forth in its erect visible form, now it shrinks back, and in its abject

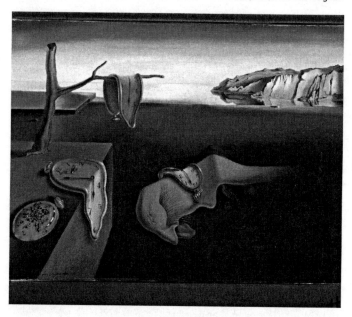

7. Salvador Dalí, *The Persistence of Memory* (1931).

depletion signifies the negation of its formerly replete state. The Lacanian phallus is the symbol of lack in the Imaginary field of vision as well as in the invisible Symbolic domain,

where its physical swelling and shrinkage mimics the now-you-see-it-now-you-don't substitutability of the signifier in the articulated chain of signification.

When viewed sharply from the side, the foreground anamorphosis in *The Ambassadors* can be perspectively re-configured as a skull, the symbol of the earthly vanity of Holbein's handsomely attired men. In the humorous delirium of his paranoiac reading, what Lacan stressed instead of the conventional symbol of death was the actual appearance of the amorphous shape itself, which reminded him of the sagging two-pound loaf of bread on the head of a woman in a sculpture by Dalí (*Retrospective Bust*, 1933, Museum of Modern Art, New York), not a loaf composed of two books according to Sheridan's English mistranslation, the word *livre* meaning either a book or a unit of weight. The anamorphic distortion of the skull also evoked for Lacan the signature Dalinian effect of hard forms becoming soft, as in the soft watches in *The Persistence of Memory* (1931, Museum of Modern Art, New York; Figure 7), perhaps the artist's single most famous work.

Like the Lacanian phallus that is nothing but the signifier of its self-cancellation, soft objects are propped up and flop over everywhere in Dalí's oeuvre. Always depicting the same Imaginary melting away of physical substance, this is the destiny of the Real libidinal being condemned to live out the missed encounters of its sexual drive in the shadow of the Symbolic foreknowledge of its own death. This is the fate of *The Great Masturbator* (1929, Queen Sofia Museum, Madrid), a soft self-portrait encoding many of Dalí's overtly Freudian symbols of sex with his mother and castration by his father. Lacan singled out this work in *Book IX* of *The Seminar*, on identification, in 1961, where he commented on the ability of some authentic works of art to retain a scandalous, critical edge at a time of increasingly banal and sarcastic diffusion of psychoanalytic imagery in the mass media. From the campy advertisements for Chiquita bananas to the earnest commercials for Viagra today, the phallus never fails to appear but as an

inflation of itself. The massive erections of Internet pornography and the endless e-mail offerings of penis enhancement products are two fallacious faces of contemporary phallic fraud. Also available on the Internet is a trenchant set of trading cards by blogger Carl Steadman and illustrator Anda Brubaker, *Kid A in Alphabetland: An Abecedarian Roller Coaster Ride through the Phallocratic Obscurantism of Jacques Lacan* (1993).

Comparing Holbein's and Dalí's distended forms, Lacan averred that the latter were no less phallic than the former, although once again the Sheridan translation errs in stating the contrary. In the anamorphic dialectic between the frontal gaze of the stain and the sidelong glimpse of the skull, Holbein made visible the oscillation between the Imaginary subject of bodily affirmation and the Symbolic subject of linguistic negation. At the Imaginary level this evoked in Lacan the masochistic fantasy of physical castration brought about by being shown the image of his own soft watch (*montre molle*), a slang French expression for 'limp dick'. At the Symbolic level, however, the very thing Lacan lost in the image of self-dismemberment was returned to him in the artful words of re-membering that the play of the signifier made possible. In the virtuoso performance of his long-running one-man show entitled 'Symbolic castration', Lacan gained a temporary protection from his inevitable objectification beneath the cruel searchlight of posterity's gaze. It is in this manner that I propose to understand Lacan's most famous declaration about painting: 'This picture is simply what any picture is, a trap for the gaze.' I perform the painting of the picture in order to trap within the caged emptiness of its frame the voracity of the Other's gaze. A more literal example of caged emptiness is found in the minimalist lattice cubes of American conceptual artist Sol Lewitt.

The line and the light

In his lecture on the opposition between the geometric line of the eye and the enthralling light of the gaze, Lacan drew on his

blackboard yet another of the diagrams with which he hoped to transmit the teachings of psychoanalysis in easily remembered visual form. Lacan's gazing triangles have become quite famous among artists, historians and critics of art.

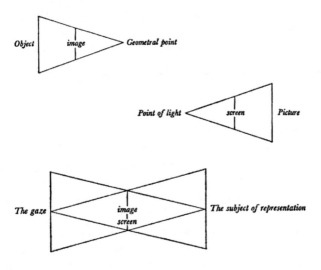

In the first triangle Lacan drew a likeness of the three-dimensional space that the eye surveys in its capacity as an optical lens. From the geometral point of the painter's eye the Imaginary rays of vision go out to encounter any object in the world. The resulting image is situated in the diagram midway between the object and the eye, where the easel of the painter might stand. This is the paradigm of linear perspective as formulated by theorists of the renaissance such as the Italian Leon Battista Alberti and the German Albrecht Dürer, the latter of whom invented a framed gridwork of threads by means of which the three-dimensional curvature of an object could be transferred as a two-dimensional projection on a flat surface. This, Lacan insisted, merely yielded a geometrical mapping of three-dimensional space

rather than an adequate understanding of the libidinal dynamics of embodied human vision.

In the second triangle Lacan assigned the inauguration of human vision not to the geometrical capacities of the eye but, rather, to the emanating power of the point of light, which seems to flow outward from the object in the world toward the subject. Illuminated by the light of the world, the subject is a picture to be seen. In the first diagram it is a matter of linear rays connecting the eye to the object, whereas in the second it is the radiance of light that engulfs the subject in its gaze. This is the sort of primordial seeing of the subject that seemed to emanate from the m/other, causing the subject to wonder: 'What do you want from me by looking at me in that way?' Lacan was not denying that a geometrical perspective of the world is registered in the eye of the seeing subject. What he wished to affirm was the ethical priority of the speaking subject over the seeing subject, the necessary supplementation of the Symbolic questions of meaningful existence over the ocular mechanics of Imaginary perception.

On such a viewing the world is not simply what I choose to regard visually with my eye but, rather, what I find myself having a vital regard for in my impassioned encounter with the world. In the second triangle this encounter between the subject of the unconscious and the environing world takes place at the midway location that Lacan labelled the screen (*écran*). It is in the screen that I am in the picture. I am in the picture not as an objectively seeing eye but, rather, as a subjectively seeking I. Unfortunately for the reception of Lacan among English-language readers, just where the analyst said 'I am in the picture' the translator inserted the diametrically incorrect 'not'. This has led to the erroneous impression in the English-speaking world that the Lacanian subject is merely the passive target of the Other's gaze, as in the view of the French philosopher Jean-Paul Sartre. On the contrary, Lacan's psychoanalytic rejection of Sartrean phenomenology

presupposes the intimate implication of the seer in the seen by means of its Symbolic identification with the Other as Ego-ideal. The screen is the singular set of signifiers that has determined me in the uniqueness of my history. It is the Symbolic grid through which I try to map my desired position within the sight of my family and my world.

Lacan also called the screen of signifiers interposed between my subjectivity and the objectivity of light the *tache*, translated as either 'stain' or 'spot'. Like the physiological eye cautiously looking at the sun's corona around the periphery of an interposed opaque screen, the psychological I must similarly protect itself from the overwhelming stimulation of being seen by the Other with the aid of the filter of the signifying screen. It is the sunscreen ointment that spots and stains my sensitive skin so as to keep it from being badly burned at the beach. My subjective screen or stain of visual regard similarly stabilises my point of view and keeps me from being undone by the raw power of a painting's dazzling, ambiguous, enigmatic gaze.

As in the ecological phenomenon of camouflage, in which the animal adapts its appearance to the environment in order to elude the gaze of its predators or the burning rays of the sun, so too in the art of painting the painter manipulates the screen in order to evade incineration under the gaze of the Thing. And who or what is the painter's Thing? It is the Other to whose gaze the artist offers the painting as an Imaginary lure in the hope that its duly constituted representatives – Mother, Father, Monarch, Patron, Critic, Public – will lay down the formidable weapon of their gaze and look kindly upon the work of art as an acceptable sacrificial gift. 'Who you lookin' at? You lookin' at me? Well, don't look at me, look at this instead and let me be.' The painted canvas is a cast-off skin to throw the Other off my trail.

The painter's desire is the desire of the Other, the desire to fill in the Symbolic lack in the Other with the Imaginary semblance of

the beautiful work of art. But there is no guarantee that the Other will see in the work what the painter seeks to show. Lacan illustrated this disparity between the eye and the gaze, between what I risk to show and what the other deigns to see, with the ancient Greek legend of the competition between the painters Zeuxis and Parrhasios. Whereas Zeuxis tricked the eyes of the birds by painting illusory grapes on which the creatures tried to feed, Parrhasios tricked his colleague's eye by painting the lifelike image of a curtain on a wall (engraving by Joachim von Sandrart, 1675). Parrhasios won the competition by evoking Zeuxis's desire to see what was hidden behind the veil, but of course there was nothing to see but the veil itself. For the hungry eyes of the birds it was the visual illusion of the object that was at stake. For the inquisitive I of the painter it was, rather, what seemed to lie unseen beneath the painted curtain that aroused his desire to see. Beneath the Imaginary mask of the Ego that we show the world there is no hidden self to see, only the invisibility of our Symbolic identification with a particular set of signifiers that always remains open to change. This misrecognition or *méconnaissance* (punningly doubled as 'me-knowledge') was for Lacan the fundamentally paranoid condition of the Ego. Facing the enigmatic gaze of the Other, the paranoid subject suspects the Other's hidden designs upon it beneath the deceptive appearance that the eye sees.

What is a picture?

So what, then, is a picture? Lacan answered this question by superimposing the triangle extending from the geometral point of the physiological eye upon the triangle emanating from the point of light in the psychological field. In the first, Imaginary triangle the eye perceives a visual image of an object, while in the second, Symbolic triangle the point of light emitted by the object passes through the invisible screen of signifiers in order to make a picture for and of the seeing eye. The two opposed triangles are fused together in the third diagram – just as are fused together the

Imaginary and Symbolic registers of daily experience – where the gaze inscribes the subject of visual representation into the painted image in the form of the image-screen of desire. Like Zeuxis looking at the curtain of Parrhasios, I ask: 'Why am I looking at this picture? What does the painter desire in showing it to me? What kind of spectator must I desire to be in order to face up to this enigmatic gaze that looks blankly out of its frame at me? What words can I use to fill up the troubling gap of uncertainty that the work of art opens up in the scopic field?'

Lacan insisted that in the scopic field the gaze was outside the subject, looking at the subject, turning the seeing subject into a seen object, into a picture. In the visual field 'I am photo-graphed,' he wrote – illuminated, lit up, written on, graphed onto a set of geometric coordinates by the emblazoning power of light. In *Book XI* Lacan no longer made explicit reference to the Thing from *Book VII* as the origin of the gaze that shone its light on me, preferring instead to point to the invisible object 'a' in order to give a vanished carnal presence to the primordial maternal face that once ignited my flesh with the flash of its gaze. In the scopic field of the subject the severing of the joint gaze of mother and child leaves behind the abject bodiless residue of object 'a'. Object 'a' is the cause of the desire to recover the lost gaze of the Thing and also the cause of the drive to reframe the visual semblance of that lost gaze in the work of art. On the one hand, from the point of view of desire, the image-screen of the diagram presents an Imaginary schema of the lost object that suggests the desire for its retrieval. On the other hand, from the point of view of the drive, the interpositioning of the screen-image protects the Symbolic subject from being reinundated by the unbearably Real radiance of the gaze. This is the gaze of the Sun, the Mother, the Son, the Matter – a sparkling watch, a glistening glass, a shiny apple, a reflective pond, a haunted house – that seems to face the subject from the transcendent place of the lost Thing. Spectators of the visual arts repeatedly encounter this object gaze in paintings, sculptures,

photographs, and films exhibited on the white walls of churches, museums and galleries, or the illuminated screens of movies, computers and high-definition TV. The blank windows of the house of the incestuously murdered mother in Hitchcock's *Psycho* stare at us with the intolerable gaze of the Thing.

The subject of Imaginary representation is also the subject of Symbolic castration, the fleshly price of which is well spent in acquiring the shield of the signifier to deflect the traumatic renewal of the primordial gaze. The image-screen/screen-image is the mask that painters manipulate in order to keep the gaze at bay. Open your body and soul to the full force of the sun at your peril, but if you hold out an image in front of you at arm's length, such as your canvas on its easel, you can screen out the centre of the sun's face, too terrible to behold, and still perceive some of its less powerful rays around the margins of the work. The Real is the unseeable central field of the gaze around which our Imaginary schemas and Symbolic signifiers unfurl their babbling banners and erect their fragile frames, and the object 'a' is the remnant-revenant of the Real that we can use to plug up the central void. The object 'a' fills up the void of the lost object's gaze and sutures the void of the signifying subject as well, three voids tied together in an empty knot – $<>@. In the art of painting an example of the object 'a' is the meaningless singularity of the painter's material touch that yet confers a Symbolic identity upon the work. 'Look, it's a Monet,' we say.

The fear of being exposed to the force of the gaze leads the painter to offer up the painting not only as a means of tricking the eye (*trompe l'oeil*) of the Imaginary other – Zeuxis vs. Parrhasios, Monet vs. Manet – but also of taming the gaze (*dompte-regard*) of the Symbolic Other, the prime example of which in the Western tradition is the all-seeing gaze of the pagan or Christian god. Employing the aesthetic terminology of the German philosopher Friedrich Nietzsche, Lacan called the pacifying effect of painting Apollonian after the Greco-Roman god of poetry and light, in

opposition to the dark ferocity of the gaze that Nietzsche called Dionysian after the god of madness and wine.

Classical, renaissance and realist art typically seek to tame or divert the omnipotent gaze by giving it something harmonious to look at. In contrast, expressionist art crudely exposes itself to the fierce scrutiny of the gaze. Lacan located a direct appeal to this anxiety-provoking gaze in the work of the Norwegian Edvard Munch, whose most famous painting, *The Scream* (1893, National Gallery, Oslo), is now reproduced in the millions on postcards, posters and T-shirts around the world. The gaze silently demands, 'Show yourself to me!', and the painter complies by thrusting forward a contorted figure seeking to answer the enigmatic call with a stifled cry, 'What do you want?' This is the anguished question that the murderer asks in Hitchcock's *Rear Window* (1954) when he is blinded by the flash of the faceless photographer who has been secretly observing him. That explosive flash in the eye is the gaze.

Informed of contemporary trends in the art world by his brother-in-law Masson, Lacan claimed to see a direct exposure of the painting to the gaze in the abstract expressionism of post-war American art. Willem de Kooning's violently brushed series of contorted, self-displaying *Women* are easily recruited into the expressionist lineage of Munch, but equally exposed to the ravenous appetite of the gaze are the non-figurative canvases filled with sulphurous colour or writhing line by Mark Rothko and Jackson Pollock. Rather than analysing a specific movement in the history of painting Lacan always insisted that it was only his purpose to inquire into the fundamental social and psychological function of art.

In probing the function of art in society, Lacan sought to distinguish his views from Freud's. He acknowledged Freud's modesty with respect to solving the riddle of artistic creation, given that it was Freud's purpose to solve a different riddle altogether, that of the neurotic inhibition of the sexual drive in

certain individuals as opposed to the non-neurotic sublimation of that same drive in others. In studying the life history of Leonardo as if it were a clinical case, Freud connected artistic creation and neurotic inhibition in the painting of the two mothers in whose eyes the painter was said to see the childhood love he had once enjoyed and subsequently lost. For Lacan this was to restrict the analysis to the Imaginary level of intersubjective reciprocity rather than to situate it at its properly Symbolic level, where the unconscious introjection of the paternal signifier would – or would not – effectuate the necessary separation of the nascent subject from its unfree maternal prehistory.

The Lacanian displacement of the Imaginary maternal fantasy by the Symbolic paternal signifier was grounded in the Freudian notion of the representative of representation (in German, *Vorstellungsrepräsentanz*). Lacan extracted this concept from Freud's writings on dreams and other language-like formations of the unconscious. As Lacan relentlessly stressed, the Freudian unconscious was not an amorphous jumble of images and affects but, rather, a space of linguistic articulation different from that of conscious speech but no less structured by the linkage and substitution of signifiers. Literally 'the setting before the subject', the *Vorstellung* is the representation in its Imaginary dimension as an image of the lost Thing. The *Vorstellung*, however, cannot represent itself directly as an image in the unconscious but must be indirectly re-presented there by its linguistic delegate or representative, its signifying *Repräsentanz*. The *Repräsentanz* re-presents the Imaginary representation in its crucial Symbolic dimension, because the image of the Thing can be represented in the unconscious only in the form of a linguistic signifier. The image of the Thing may be hauntingly irrepressible, but its linguistic signifier may be repressed and thus, perhaps, reconfigured and released.

Given the universal task of answering the question 'Am I a man or a woman?', there was for Lacan one signifier that represented the

entire field of unconscious signification for men and women alike. This signifier-without-signified was the Symbolic phallus in its function of instituting a provisional space of lack which other signifiers could rise up to fill. The self-negation of the phallus, whereby its temporary tumescence was cancelled in its inevitable detumescence, equipped it to inhabit the purely ambassadorial role of representative of representation. As *Vorstellungsrepräsentanz*, the phallic signifier inaugurates the Symbolic play of absence and presence that structurally undergirds the representation of any content whatsoever. In its self-annihilation as organ, the phallus of Symbolic castration constituted exhibit one of Lacanian sublimation.

In Lacan's curt summary, Freud's understanding of sublimation was said to miss this essential Symbolic dimension. The work of art not only gratified the artist, Freud claimed, but also others, who were consoled that at least some in society could find satisfaction of their desire. Lacan radically reversed this idea by insisting that it was the renunciation of satisfaction that art afforded the spectator. Art permitted the individual to renounce the neurotic compulsion to enjoy. Whereas Freud was claiming that the artist and spectator wished for the satisfaction of their incestuous maternal fantasy, Lacan was declaring instead that it was art that protected the artist and spectator from getting too close to the incestuous maternal Thing. And how does art protect us? By making clear the difference between the welcome pleasure of the representation of the Thing and the undesirable enjoyment of the Thing itself.

From the most realist to the most abstract of works, art openly pretends to be what it is not. Even the most literal-minded installation art, such as *One and Three Chairs* (1965, Museum of Modern Art, New York) by American conceptual artist Joseph Kosuth, involves the spectator in a fictive dimension within the artificially framed space of the gallery. Lacan indicated that we take cognisance of this productive pretence when the mobility of

our gait causes the momentary stasis of the gaze of the work to fail. We have but to move to escape the *Mona Lisa*'s sinister gaze, to elude *The Ambassadors*' unsightly stain, at which point the Imaginary allure of the work is reduced to the depleted status of the severed object 'a'. The subject of art was repeatedly urged by Lacan to eschew the illusory plenitude of the image and identify itself with that abject material turd.

Despite his objection to performing an act of art-historical narration, Lacan nonetheless offered his audience a whirlwind tour of the gaze in its various epochs of incarnation. There was the gaze of Byzantine icons of Christ that held the medieval community of worshippers within its heavenly thrall. Lacan noted that the icon painter would have unconsciously counted on the fact that Christ himself would be looking with pleasure at this gift of his own represented gaze. Following the medieval reign of the gaze of God came that of the renaissance ruler, whose invisible gaze the spectators would have unconsciously registered behind their backs, as it were, in the Venetian palace of the doges or in the palace of the kings at Versailles. And then, in the third epoch of post-antique Western art, it was the capitalist gaze of the buyers and sellers in the commercial art market of the nineteenth and twentieth centuries through which ordinary people would have unconsciously processed the signifiers of the works on display. 'I may not be a Rothschild, a Rockefeller, or a Saatchi, but I know what I like.'

It was Lacan's conviction that the fundamental function of art had little to do with the realistic imitation of the visual appearance of the world for the pleasure of the human eye. He credited Merleau-Ponty for helping to overturn this optical prejudice by understanding the painter's material brushwork not as the fashioning of a visual equivalent of a seen object but, rather, as the terminal result of a passionately embodied sacrificial gesture in the face of the hungry gaze of the Thing. The primary example that Lacan took from Merleau-Ponty was Cézanne's application of paint

to the surface of the canvas. In these individual pats of paint Lacan saw not a deliberate intellectual choice, but the involuntary trace of an almost instinctual act that he likened to the falling of rain. Preserved on the canvas was Cézanne's unconsciously coerced response to the gaze of the Other before which he anxiously laid down the arms of his gaze.

Lacan predicated the mirror stage face-off of the alter Ego of the subject and its specular ideal Ego upon the asymmetrical encounter of the speechless infant with the unfathomable mystery of the gaze of the Thing. It was this primordial stage of encounter with the Other that invested art with a fundamental theatricality and made the manufacture of every work into a battle where victory could not be guaranteed. Therefore, a piece of painting, sculpture or architecture should never be reversed in the misprojection of a photographic slide because the essence of art was to enshrine in a living showcase a unique series of ritual gestures by means of which one hoped to appease the silent demand of the inscrutable gaze. From shitting in a pot beneath the gaze of the Other we subsequently find ourselves squeezing our coloured pigments from a tube. In that masochistic separation from ourselves of the abject part, the faeces, the droppings of matter that we offer to the Other's sadistic gaze, we participate in the simultaneous co-production of the mutilated object 'a' and the evacuated signifying self – $\$<>@$. In 1961 the Italian conceptual artist Piero Manzoni produced ninety cans of *Merda d'Artista* (*Artist's Shit*), one of which is on display at the Tate Modern in London today.

But if the demand of the gaze is silent so too is the response. The eye made desperate by the gaze seeks relaxation from its duress by making still more art, by showing still more art, by viewing still more art, again and again and again. And that is why we have an endlessly changing yet repeating history of art. For Lacan, the multifariousness of historical change in art amounted to so many failed efforts of the subject permanently to parry the power of disarray of the Other's gaze.

Chapter 6

Representative of representation

Organised around the emptiness of the lost object, the painting is a trap for the gaze (*piège à regard*). The avid eye of the spectator is tricked (*trompe l'oeil*) into feeding on the Imaginary fruit of the visual representation so as to enable the painter to tame the adversarial force of the other's insubordinate gaze (*dompte-regard*). The ordinary spectator may give in to the painter's gambit and lay down the weapon of his or her gaze, but tradition's old masters will respond to the painter's gamble with nothing but a blind, inhuman stare. The truth in painting is articulated in the face of this enigmatic silence by means of the Symbolic language of visual representation. Here the Imaginary unity of the work with which the painter captures the eye of the spectator is shown to be the fictive product of Symbolic construction. The transparent window of perspective is shown to be what it truly is, an opaque screen.

This upsurge of the screen is what took place when Lacan looked away from the Imaginary transparency of *The Ambassadors'* frontal gaze. Looking from the side, Lacan found that the illegible foreground shape of the frontal view addressed him as the Symbolic cypher of death, the signifier of his own castration. Disclosed as the signifier that rendered null and void all Imaginary effects of vivid life, the death drive of the anamorphic skull was reinscribed in the artist's signature on the marble floor of the painting: Holbein, Hollow Bone. It was thus that the artist sublimated himself as a being not wholly given over to the animal cycle of life but consecrated instead to a meaningful human

death. Not visually depicted within the Imaginary space of the work, the author was made Symbolically present in the signature that functioned as an indexical X marking the spot where once he had been.

Las Meninas

In a month of unpublished lectures from *Book XIII* of *The Seminar*, on the object of psychoanalysis, Lacan focused on a painting that put the painter inside his own work. This was the 1656 masterpiece at the Prado Museum in Madrid by Diego Velázquez in which the painter showed himself at work on a large canvas in the royal palace alongside the five-year-old Princess Margarita and her maids of honour, the latter providing the Spanish title, *Las Meninas*, by which the painting is known today (Figure 8). As in the seminar of 1964, it was again a cultural event in Paris that inspired Lacan's encounter with the art of painting: the anticipated publication in 1966 of *Les Mots et les Choses* (translated as *The Order of Things*) by Michel Foucault, the controversial philosopher and historian of psychiatry, sexuality, knowledge and power. Originally published as an independent essay the previous year but subsequently given the position of honor as the first chapter of the book, Foucault's virtuoso analysis of the complex play of gazes between the painter, the spectator, the princess and her royal parents, whose faces are dimly seen in a mirror in the background, immediately gained an authoritative place in art history and cultural studies that it has not forfeited since. Conversely, in the subsequent proliferation of commentary on *Las Meninas*, Lacan's unpublished lectures have been virtually nowhere taken into account. Here was a painting of the gaze before which the spectator could not help but to experience disarray.

In placing his analysis of *Las Meninas* at the beginning of *The Order of Things: An Archaeology of the Human Sciences*, Foucault was literally proposing a picture of the intellectual representation of the world during the early modern period of the seventeenth and

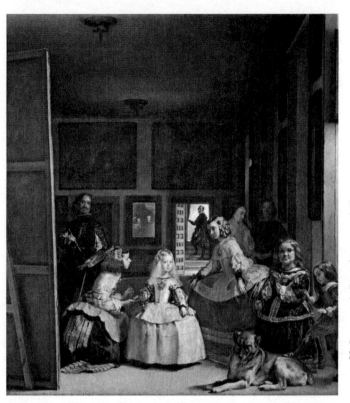

8. Diego
Velázquez, *Las
Meninas* (1656.)

eighteenth centuries. In this 'representation of
representation' there was an essential void, as
Foucault put it, that marked the absence of the
observing subject from the observed object, an
object that was imagined to exist in the world
independently of the subject's act of observation.
In *Las Meninas* this meant that the painter
working on his painting could represent either
the represented object, the canvas turned away
from our gaze, or the representing subject, the

painter looking out of the painting. He could not represent at the same time both the active subject of representation and the passive object of representation. Since what we see is the frontal image of the painter in a suspended instant of the act of painting, we cannot see the depicted content of the back-turned painting upon which, supposedly, he has just been at work and to which, supposedly, he will soon return.

Looking away from the large canvas upon which his work appears to be suspended, Velázquez seems to be addressing a subject outside the visible space of the painting where the model would initially have stood, and where every spectator thereafter would come to stand in the model's stead. For Foucault, the painter's once living model was none other than the royal couple, King Philip IV and Queen Mariana, whose pale visages are reflected in the mirror hanging on the wall behind the painter. Facing the painter's outward gaze, the spectator would come to feel as if he or she were a usurper of the monarchs' sovereign space. In Foucault's imagining of an endless exchange of gazes between the historical painter and his royal models as well as between the painting and latterday spectators, there was an illusory structure of reciprocity that Lacan had identified as that of the Ego and the other upon the mirror stage. It was the rupturing of this Imaginary visual reciprocity with the Symbolic signifiers of unconscious desire that provided the basis for Lacan's critique of Foucault.

As enunciated in *The Four Fundamental Concepts of Psychoanalysis*, the spectator in front of a painting not only sees the picture from the geometric point of the eye but is also turned by the painting into a target-like picture as the desiring subject of representation. I may imagine that I control the angle of visual access to the space of the painting that I look at, but something in the painting surprises me with its return gaze from a decentred point that strikes me in the subjective intimacy of my desire. Speaking of photography in *Camera*

Lucida (1980), Roland Barthes later distinguished between the appearance of the image that all are free to study (*studium*) and the singular point that punctures (*punctum*) the avid eye/I of an individual viewer.

Just as the incorporeal subject of linguistic representation is a signifier for another signifier (and another and another…) in the endless unrolling of the chain of signification, so too the embodied subject of visual representation is nothing more than a coloured spot for another coloured spot during the moment-to-moment process of optically scanning the framed surface of the painting. I accede to the kind of virtual subjecthood that language affords – $ – by attaching myself to the signifiers that one after another are articulated, for example, right here on this printed page by means of the more or less competent gestures of my typing fingers. I accede to the different sort of concrete objecthood that painting affords – @ – by finding that my gaze is attached to one after another spot of coloured paint, the affectual accumulation of which constitutes me as a wordless subject of the scopic drive.

In the Symbolic register of words I represent the world to myself through an intervening screen fabricated from the signifiers associated with the drama and trauma of my own unique history as a woman, a man, an Asian, an African, a Christian, a Muslim, a Hindu, a Jew. In the Real dimension of the visual domain that lies beyond the reach of words I expose myself to the world through an interposed window ringed with the colours and shapes that are the remains of my missed libidinal encounters in the scopic field. The Real window of the drive and the Symbolic screen of desire are mutually sustained by the Imaginary frame of the work of art – $<>@.

If the signifier of my name is my representative or delegate to the interpersonal community of language and language-like codes in which I live my speaking life, my equivalent representative in the setting of visual representation is the invisible phantom of

my own object 'a'. In the face of the challenging looks inscribed within *Las Meninas*, what falls within the interval between me and my depicted counterparts is the elusive object of the gaze. Lacan said that I lower my eyes beneath the force of the gaze of the painting as I might drop my pants in the face of the Other's compelling demand for the discipline of the potty. The essence of painting is therefore not the Imaginary semblances of representation but, rather, the Symbolic sublimation of Real shit. If I subtract the Imaginary ideal Ego I would like to be as an exemplary spectator-excretor from the Symbolic Ego-ideal that transfixes me in front of the potty-painting, there remains a wordless and imageless remnant of the Real. This is the object a, the meaningless residue of undisciplined visual and fecal jouissance around which the drive stubbornly turns. Whereas Freud concentrated his investigation on the role of the unconscious signifier in the repression and expression of desire, Lacan claimed that it was his original contribution to psychoanalytic theory to insist on the division of the subject not only by the rhetorical effects of language, but also in regard to the visual topology of the scopic drive.

In the first decade of Lacan's seminar, between 1953 and 1963, the stress was on the division of the subject by the effect of the signifier, the alien mark that constituted the unconscious at the moment of the death of the creature of fixed animal instincts and its simultaneous rebirth as the nascent subject of highly variable human drives. In the exchange of Real animal being for Symbolic human meaning a force of signification was set in motion to counteract the coercive identification with the Imaginary counterpart of the mirror stage. This vexed encounter of the self and the other was not yet seen to leave behind the Real residue of the object 'a'. This uncanny object began to come to the fore in the formula of fantasy of the Graph of Desire – $\$<>@$. Now the visual fantasy was seen to hold together in precarious balance the split subject of the unconscious and the lost object 'a' of

primordial corporeal enjoyment. The Real pressure of bodily needs could be translated into the Symbolic articulation of spoken demands for attention and love, but an inevitable residue of unsatisfied desire endured.

In the second decade of Lacan's teaching, roughly from 1964 to 1973, the stress shifted from the alienation of the subject in its speaking role of Symbolic castration (or loss of corporeal being) to the separation of the embodied subject from the signifying chain upon which its subjecthood had hitherto seemed totally to depend. Now Lacan looked more and more to painting rather than language as the medium within which a shred of lost corporeal enjoyment might be redeemed in the form of the object 'a'. Standing in front of Leonardo's *Madonna and Child with Saint Anne* in 1957, Lacan saw in the infant Jesus the image of the lost maternal phallus of classical Freudian doctrine. Standing at the side of Holbein's *Ambassadors* in 1964, Lacan saw in the anamorphic skull the symbol of his own excommunication from the official institutions of psychoanalysis. Travelling beyond the boundaries of orthodox Freudian theory, Lacan carved out for special investigation the subjective space of the scopic drive. The loss of the Imaginary object of visual desire continued to be understood in relation to Symbolic castration, but also increasingly in relation to the Real loss of the maternal-infant gaze.

Moebius strip

In thinking about the gaze as the Real object of the scopic drive, Lacan insisted on the topology of the eye as an erogenous zone, opening and closing itself to external stimuli such as naked bodies and bared surfaces of paint. The rhythms of the eyelids mediate the ocular relation of the body to the world, and Lacan was struck in *Las Meninas* by the heavily lidded gaze of the depicted painter, who appeared to him to look inside as much as outside from his ambiguous position within the shadowy space. One of Lacan's images for this oscillation of the gaze between outwardly turned

vision and inwardly turned fantasy was the Moebius strip, a structure consisting of a continuous loop with only one side. Imagine a loop made of a tailor's measuring tape with inches marked in red on one side and centimetres marked in black on the other and upon which a red ant traverses the outer side marked in inches while a black ant does the same thing on the inner side marked in centimetres. Isolated from one another in this fashion, the red ant will never encounter the world of black landmarks nor will the black ant ever cross the red demarcations on the nether side of its world. This either/or exclusion, however, is overcome in the Moebius strip, where a single twist of the tape permits the red side to be directly connected to the black. In the time and space of a single step the red ant traversing its familiar pathway of red inch markers traumatically finds itself caught up within an alien network of differently calibrated black lines. The woodcut *Moebius Strip II (Red Ants)* of 1963 by the Dutch artist M. C. Escher provides the striking cover art for the 2004 publication of *Book X* of Lacan's seminar on anxiety of 1962–3.

In Lacan's appeal to a continuous surface of mathematical topology rather than the discontinuous segmentation of language, he was asking his audience to imagine the interaction of art and the human being as a Moebius membrane connecting the outside to the inside across the threshold of the body's orifices. Food enters the mouth and spit and vomit are expelled from it. The penis is inserted into the vagina or the anus and urine, faeces and menses are excreted from the body. Sights penetrate the eyes and tears spill outward upon the surface of the skin and drip, perhaps, into the morning coffee. So it is with the affectual residue of the invisible scopic object that binds together the physicality of the body and the materiality of the work of art in a continuous, sublimated loop. As the world of the ant is transformed in its Real crossing of the Imaginary border from red to black, so too the Real impetus of the scopic drive propels the Symbolic subject of language beyond the Imaginary

boundaries of the body as it encircles the lost object reframed in the work of art. After encircling the object 'a' located outside itself in the work of art the subject of the drive returns to itself renewed.

In works of artistic sublimation the Symbolic subject envisions the Imaginary object in order to extract from it a surplus spurt of Real jouissance. Like the patient in analysis who seeks to traverse the path of his or her innermost fantasy through the deployment of spoken signifiers in the silent presence of the analyst, the visual artist performs the risky business of self-analysis by conjuring up in material form the uniquely configured contours of his or her object 'a'. Neither exterior nor interior, conscious nor unconscious, the twisted topology of this intimate object was described as 'extimate' by Lacan.

The lost object 'a' of the scopic drive is neither the gaze that once glowed in the mother's eyes nor that which once glistened in the eyes of the child, although this is the reciprocal model relied upon in Freud's tale of Leonardo's lost smile. The gaze that Lacan found materialising itself between his desiring eye and Velázquez's desire-inducing painting was an uncanny object impossible to describe in words. Nevertheless, I like to imagine it as an inflatable balloon with four prongs that once filled up the interval between – and plugged into the optical orifices of – the primordial Thing and the wordless infant. So why do we look at art? In order to breathe fresh air into the deflated balloon of the invisible lost gaze.

Human desire is the desire of the Other, Lacan said tirelessly. Whose desire, then, was at stake in *Las Meninas*? Lacan conceded that Velázquez surely had a desire for the Other's desire, perhaps in the form of the cross of nobility that was ultimately awarded to him and which, according to legend, was painted on the breast of his self-portrait in *Las Meninas* by the king himself. But Lacan always insisted that his interest was not in the art-historical or psychoanalytic reconstruction of the lost intention of the artist.

His concern was to lay bare the scopic structure of the painting as an analogy for the unconscious structure of the subject as it was exposed in psychoanalytic treatment. For Lacan, *Las Meninas* exhibited the fundamental dialectic of human desire, here made manifest in the enigma that the painter's turned-away canvas represented for the gaze of the principal actor at the centre of this little play, the Princess Margarita, who demands: 'Show it to me!' Speaking from the position of the analyst situated in the consulting room behind the analysand who wants to know what she supposes the analyst knows about her, Lacan's Velázquez replies: 'You don't see me from the place that I see you. You look at me with the Imaginary eye of wishful reciprocity, whereas I look at you with the disillusionment of the Symbolic gaze within whose signifiers the articulation of your desire is trapped. Whatever I might feign to show you would not be what you want to see.' This asymmetry between the gazes of the analyst and the analysand was recently restaged in the installation of an analytic couch and chair in a large ventilated plastic bubble by the Argentinian artist Pablo Reinoso, *The Cabinet of Dr. Lacan* (1998, private collection, Paris).

We can recognise in the psychoanalytic scenario of duelling desires a repetition of the demand of the ancient Greek painter Zeuxis for his rival Parrhasios to show him what was behind the curtain that he saw on the wall. Here again we encounter the trick of fooling the spectator into believing that there is something beyond the mask of appearance even though there is not. There is no Other of the Other, Lacan repeatedly insisted; no guarantee that there is someone who knows what is going on behind the scenes, not God, not the Wizard of Oz, not the psychoanalyst, although perhaps with this difference that the Lacanian analyst claims to know that she or he does not know the secret of the analysand and that that is the truth.

In the age of classical representation the philosophical certainty of one's own physical existence required the guarantee of

an omnipotent, omniscient and benevolent God. Such a God could not be expected to take advantage of the fallibility of our senses as revealed in hallucinations, fevers and dreams. Similarly, it was the implicit presence of the all-seeing gaze of the absolute ruler of the seventeenth century that guaranteed the effective force of the representation to which all its subjects were subjected. In *Las Meninas* the significance of the representation of the princess and her maids of honor depended upon the disembodied gaze in the mirror of her royal parents, whose ruling desire it was that she was to be their heir. For Lacan, however, Velázquez put that fundamental law of courtly representation into doubt by revealing that its elaborate visual fabric was the product of nothing more than a figment of pigment applied to a canvas that might forever remain blank. The rationalist slogan of Descartes, I think therefore I am – in French, *je pense donc je suis* – was thus challenged by the materialist rebuttal of Velázquez, *je peins donc je suis*: I paint therefore I am. I, the subject of the painted signifier, accede to a small measure of jouissance by smearing on canvas the pigment-shit of object 'a'.

Foucault was personally in attendance at one of the lectures in which Lacan elaborated his alternative libidinal approach to the topological mapping of Velázquez's picture puzzle. What did the mirror show? Foucault claimed that in the mirror we see the reflection of the monarchs who are standing outside the visible scope of the painting as if in the place that we spectators now stand. The invisible rulers are the object of regard of the princess and her attendants and the object of the pose by the painter, who represented himself portraying the king and queen on the large canvas whose back alone we see. Lacan disagreed with this view of the picture, insisting that the back-turned painting was *Las Meninas* itself.

For Foucault, the mirror exhibited a Real reflection. For Lacan, the mirror was not to be understood as the Imaginary semblance of the royal personages within an actual physical space but, rather,

as the Symbolic inscription of their absolutist gaze within the world of representation that was the Spanish court. Velázquez's painting within the painting further called attention to the representational status of the entire painting, thus, in Lacan's metaphor, supersaturating the pictorial solution so that it precipitated out into the crystalline structure that captivates our gaze. *Las Meninas* was understood by Lacan as the pictorial representative of the ideological representation of the Spanish court, the *Vorstellungsrepräsentanz* by which the unrepresentable anxiety of the Real was given a necessary but insufficient Imaginary representation in the Symbolic art of a painted sign.

As the material representative of an immaterial representation, the painting sutured together two incompatible elements according to the formula of fantasy – $ \$ <> @ $: the subject divided from its immediate corporeal enjoyment by the mediation of language, and the invisible object 'a', the remaining shred of unmediated scopic contact with the terrifying desire of the wild Thing. The reappearance of the lost scopic object reframes the penetrating gaze in which the Desire of the M/Other was enigmatically embodied in the past. 'Why are the painter, the princess, and her parents looking at me? What do they want? And what do I want of them?'

Lacan approached these questions in the Freudian language of phallic desire. He saw the gaze in the painting aiming at him in the intimacy of his own castration anxiety from beneath the dress of the princess, where he imagined an unseen crack (*fente*) in the royal representation. In the invisible place of the future sexuality of the five-year-old princess Lacan envisioned the Imaginary phallus in its illusory capacity to gratify the desire of the king and queen that Margarita be their heir and the redemptive hope of their failing royal fortunes.

Whereas Foucault analysed *Las Meninas* in terms of the realist sight in the mirror, Lacan encountered the work with a paranoid surrealist insight regarding the deception of optical appearances.

In a prefatory statement on his intellectual antecedents written in 1966 for the publication of *Ecrits*, Lacan acknowledged the influence of Dalí on the development of his anti-realist stance. The paranoid Dalinian universe of soft penile watches had already been invoked in 1964 in the face of the anamorphic skull of Holbein's *The Ambassadors*, so it should come as no surprise that the Oedipal drama of incest and castration would again figure at the heart of Lacan's analysis of Velázquez's 'Family of the king', this being one of the early titles of the work. For in the demand of the princess to see the hidden truth of the painting we have a version of the female hysteric who challenges the masculine figure who would wield authority over her person. In Lacan's delirious fantasy the princess repudiates her assigned role in the drama of dynastic marriage in which her body was the predestined currency of patriarchal exchange.

At the time of being painted in 1656 Princess Margarita was the official heir of her father, King Philip IV of Spain. His son by his first wife had died in 1646, and soon afterwards, at the age of forty-nine, he married his dead son's fiancée, his own fourteen-year-old niece, Mariana of Austria, whose face alongside his own we see in the mirror on the back wall. Within a year of Velázquez's painting the queen gave birth to a son and with that Margarita ceased to occupy the centre of her father's dynastic aspirations. Here, however, the five-year-old princess is still uncomprehendingly asking, 'What do you want of me? What does it mean for me to be treated as the Imaginary phallus of the Hapsburg House?' Her dress tightly nipped in at the waist above a lateral expanse of fabric that constructed the visual fantasy of a mature pelvic girth that was not really there, the young princess embodied a wishful emblem of royal fecundity. A floral bouquet of marriage is prominently pinned upon her breast and a pronounced dark shadow marks the split between her legs directly below the broad fabric crescent that both screens her genitals from sight and also points to their absence.

This duplicity of revealing and concealing the Imaginary phallus constitutes the psychoanalytic definition of the fetish, and as such the masculine fantasy of the phallic princess comprised for Lacan an exemplary sign of castration anxiety. In the smooth verticality of the prepubescent girl's body Freudian psychoanalysts and surrealist artists saw an equivalent of the Imaginary phallus. Her premature sexuality and perverse erectile function are emphasised in many of Picasso's forty-four painted variations on his predecessor's masterpiece that he made in a great burst of activity in 1957, and which Lacan might well have known. In one telling picture Picasso extracted the princess from the group portrait and showed her reaching for a phallic paintbrush proffered to her on a plate (Picasso Museum, Barcelona).

The painter, the princess and one of her dwarf attendants look out from the foreground of *Las Meninas* into the spectator's space. Entering into this space of uneasy encounter, we bring with us the habits of seeing and knowing through which we have come to represent the world to ourselves. On the one hand, there are the screens of linguistic signifiers that we hold out in front of us to accommodate the pictorial representation to the predetermined representations of reality that we are variously prepared to acknowledge as women and men. On the other hand, there are also the characteristic voids left behind in us in the wake of the loss of our own most intimate objects. These primordial objects constitute no screens of articulate language nor surfaces of visual reflection, but their loss opens up the very possibility of representation as such. These are the precursors of the representatives of representation of which the template was set at the time and place of the mirror stage. There the non-speaking child found itself playing a subjectifying game of peekaboo with its objectifying image, being sure all the while to check the effects of this game of enticements and feints upon the adult or adults who supported its unsteady body in front of the looking glass. Unstably fused together, our screens of language and spaces of loss construct

the fragile frames of the windows through which we regard the world.

The spectator stands in his or her window looking at *Las Meninas*, and from inside its frame *Las Meninas* looks back. If the diameter of that frame exactly matches that of the spectator's window there will arise an Imaginary effect of realism, with Velázquez's representation coinciding with the representation unconsciously brought to the encounter by the spectator, whether king, queen, princess, dwarf, Picasso, Foucault, Lacan, me, or you. But the apparent veracity of *Las Meninas* will be called into question, and its pretense of representation laid bare as the product of the Symbolic manipulation of representation's representatives, if so much as a crack of discrepancy lies between the painting's frame and the window through which the spectator unconsciously looks. According to Lacan, Velázquez undercut the Imaginary consistency of the court by painting an uncanny image of the king and his queen in a Symbolic mirror that appeared to violate optical law.

In the dark glimmer of the royal mirror Lacan saw a premonition of the television screen of the media age. Relations of insatiable desire between the post-war European subject and the commodities of American-style capitalism were offered a spectral existence on the black and white electronic screen. Given his harsh critique that American-style Ego psychology merely encouraged patients to adapt themselves to prevailing capitalist norms, Lacan might have been amused to rebrand the USA national corporate logo as U$@. My condensed formula is meant to convey the idea of the Unconscious repression of the structural conflict between the empty formal $ubject of liberal democracy – One man, one vote – and the harassed physical @bject of global consumerism – Shop till you drop! Although artworks are often reduced to playing the role of luxury commodities, in the authentic work of art subject and object are uneasily brought together face to face. In 1986, on a large electronic billboard in front of the

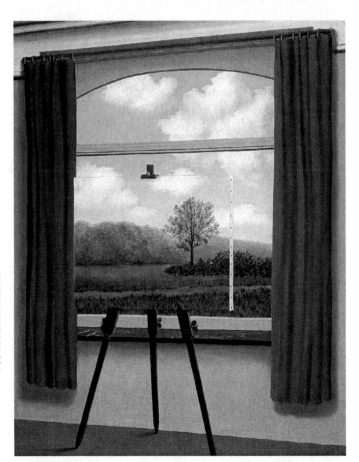

9. René
Magritte, *La
Condition
humaine*
(1933).

Caesar's Palace casino in Las Vegas, the American conceptual artist Jenny Holzer erected one of her trademark signs that speaks directly to the contradictions of capitalism and desire: 'PROTECT ME FROM WHAT I WANT.'

Velázquez underlined the status of his pictorial representation as the material representative of a fictive courtly representation in a number of ways. The painter indicated the gaze of the sun, upon which pictorial representation depends, in the luminosity of a window aperture that is all but unseen at the right edge of the painting. He imitated the perspectival piercing of pictorial space by opening a door in the back wall onto a flight of stairs to a distant hall. And he painted images of other framed paintings on the walls of the room. Above all, Velázquez acknowledged the fundamental constructedness of pictorial representation by depicting himself next to a massive canvas on its wooden stretcher with paintbrush and palette in hand at a moment of arrested gesture and suspended gaze. It was the presence of this painting in the painting that freed *Las Meninas* from the illusory representation of representation that Foucault insisted upon, making it instead into a frankly declared representative of representation in the language of Lacan.

The Human Condition

In order to clarify his claim, Lacan turned to a surrealist work by Magritte, who shared with the psychoanalyst the desire to liberate twentieth-century culture from the Imaginary shackles of realist representation. In *The Human Condition* of 1933 (National Gallery of Art, Washington; Figure 9), Magritte situated a landscape painting on an easel in front of a window opening onto that very same landscape in such a way as to make the painting all but disappear into the exterior view. Crucially, however, Magritte repudiated the illusion of continuity between the work and the world by twisting the plane of the painting out of a strictly parallel relation with the pane of the window. As a result of this displacement the painted canvas was shown as both passing beyond the limit of the outside view and failing to achieve coincidence with it: on the left, the edge of the landscape on the easel very slightly overlaps the curtain that enframes the window

behind it, and, on the right, the painting's unpainted edge of tacked-on canvas narrowly obtrudes upon the transparency of the window view. Seen from the side in this fashion, like Holbein's anamorphic skull, Magritte's painting within the painting was freed from the ideological duty of ratifying the conventional representation of reality. Instead, the canvas openly proclaimed the artificial status of the work as a Symbolic representative of an Imaginary representation of the world. And the Real distortion produced by the slightly skewed angle of vision opened up an irreducible gap between the eye and the gaze, between the Imaginary representation of the view through the window and the Symbolic representative of the painted surface of the canvas. This gaping wound in the human condition is the lost place of the object 'a'.

As for the back-turned canvas in *Las Meninas*, we can make it approximate the orientation of the canvas in *The Human Condition* by swivelling it to the left around the hinge of its visible left edge, until the hidden front surface of the painting begins to emerge into view and eventually superimposes itself completely over the depicted scene. If the resulting superimposition of the painting were totally to coincide with the view of the room that remains visible beyond its margins, it would then conform to Foucault's Imaginary representation of representation. If, however, with Magritte, we were to arrest the swivelling gait of the canvas across the painting's front just before its unpainted edge disappeared into shadowy oblivion, then, with Lacan, we would be confronted by the literal materiality of the Symbolic representative of representation. In this respect Velázquez the painter would be like Lacan the analyst, poised to remark upon the Real unconscious breaks in the consciously spoken discourse of the analysand. As for the honorific cross painted on the artist's chest, which dedicated his efforts to a Symbolic company of the noble dead rather than to the Imaginary flux of daily life, Lacan confirmed his own paranoia of martyrdom by insisting that he did not regard himself as having been

crucified by his excommunication from the international psychoanalytic community.

Lacan spent the better part of six lectures in 1966 reconstructing the deadly play of the gaze in *Las Meninas* in view of his creation of a new psychoanalytic entity, the lost object of the scopic drive, the primordial cause of the severed subject's scopic desire. Lacan returned to the example of *Las Meninas* in the unpublished fifteenth book of *The Seminar* on his conception of the psychoanalytic act. He did so in order to clarify the ethical responsibility of the analyst to account for the presence of his or her own gaze within the discourse of desire of the analysand. Lacan claimed that the analyst had to take up a position within the work of analysis like Velázquez within the work of art.

In painting, as in psychoanalysis, the gaze is both present and veiled. The analyst is supposed to know the hidden cause of the suffering of which the patient is ignorant, just as the painter is presumed to know the laws of perspective by which the world takes on its form for the princess at her father's court. In *Las Meninas*, however, the painter did not represent his presence in the painting as the absent Imaginary eye of the objective perspective. He portrayed his own subjective gaze present but suspended within the Symbolic setting of the artist's studio in the palace of the king. Lacan equated this hiatus between seeing and painting to the gaps in discourse through which the consciously unknown knowledge of the subject was unconsciously given voice.

In Velázquez's self-representation as both the active painter of a picture and a passive picture within that very painting, the courtly spectator might have felt robbed of the comforting illusion that art can array the world before his or her eye as an object of Imaginary perception without implicating his or her own gaze of Symbolic agency. Even in the painter's self-portrait Lacan saw that there was no mirage of immediate presence. Adhering to cultural convention, Velázquez depicted himself wielding his brush not with his left (sinister) hand, as the reversed image in the mirror

would have shown, but, rather, with the right (dexter) hand with its superior Symbolic connotations. In *Self-portrait with Palette* from 1879 (private collection), Velázquez's admirer Edouard Manet repeated the Symbolic stance of the master, but unlike his Spanish realist predecessor the French modernist acknowledged the Imaginary reversal of the mirror according to which his apparent left hand holding the brush was reduced to the impossible Real blur of the lost object 'a'.

As Manet's self-portrait demonstrates, a hand engaged in the dynamic act of painting on canvas cannot at the same instant take on the stilled appearance of an object seen in a mirror. For Lacan there was a similar split between the analyst's active attention to the articulation of the analysand's discourse and the analyst's passive reflection of the analysand's image of the analyst as an all-knowing gaze. It was to this presupposed gaze of knowledge that the patient's discourse had been addressed since the moment when its suffering had become a question to be answered by a knowing Other. As with the painter and the princess, the transference of the supposition of the knowing gaze to the psychoanalyst was the projection on the part of the patient that there existed someone who truly sees and truly knows. 'So show me!', she said. But the painter of the princess did not budge, because, like the silent analyst, the Other sees and knows nothing at all.

Chapter 7

Am I a woman or a man?

Lacan's seminar on the psychoanalytic act was disrupted, like all things in France, by the revolutionary acts of May 1968. Dissatisfied with conditions in the government-run universities, students took to the streets, chanting revolutionary slogans with a distinctly Lacanian ring: 'Be realistic, demand the impossible!' Although Lacan regarded the violent confrontation with the police not as a properly psychoanalytic act couched in the Symbolic medium of words but, rather, as an Imaginary, inarticulate acting out by the students addressed to a government that was deaf to their desires, he nevertheless suspended his seminar for a month in solidarity with their grievances. A year and a half later, in an impromptu meeting at the experimental branch of the University of Paris at suburban Vincennes founded in 1969 in response to the protests of the previous year, Lacan cautioned his still confrontational auditors that they take care not to squander their revolutionary ardour in narcissistic self-display. As a cautionary image he offered the students the futility of the bride-obsessed bachelors who grind their chocolate themselves in the signature work by his recently deceased friend Duchamp, *The Bride Stripped Bare by Her Bachelors, Even*, commonly known as *The Large Glass* (1915–23, Philadelphia Museum of Art). The first three letters of bride – MARiée – and bachelor – CELibataire – spell out the artist's bi-gendered name, Marcel/Marcelle, in a Duchampian wordplay that is typically Lacanian as well.

In June 1968 Lacan returned for a final session of his seminar after civil order had been restored in France. Perhaps we can see an eloquent image of the nation's tragic self-stifling in Lacan's reading on that occasion of Munch's famous painting of 1893, *The Scream*, as the silenced voice of desire subjectively annihilating with its hysterical shock waves the rigid, black-frocked masters of bourgeois convention who are shown walking imperturbably along the vertiginous perspective of the bridge. Making himself the suffering mouthpiece of the Symbolic truth of unconscious speech, Lacan returned to his reading of Munch's *Scream* as a muted cry into the unheeding void at the first session of the sixteenth year of his seminar, the last to be held under the auspices of the Ecole Normale Supérieure. Dismissed for his role in promoting the subversive discourse of psychoanalysis in the French university, Lacan could take perverse pleasure in yet another excommunication like that of his beloved Spinoza. But not for long. Starting in 1969 his seminars would henceforth be hosted at the Law School of the University of Paris at the Pantheon.

Entitled *From one Other to an other*, Book XVI of *The Seminar* distinguished between two forms of the other/Other: the upper-case, generalised Other of linguistic, cultural and political authority in whose signifiers the subject fails to achieve anything but an empty shell of rhetorical consistency, and the lower-case, singular other of the object 'a' in the lost physicality of which the subject may find its only Real coherence of self. The object 'a' of Munch's silent scream represented for Lacan the trace of a lost embodiment once situated within the matrix of the mother-infant embrace. Only a hole in the subject's being subsisted as a place-holder of this evacuated jouissance, a hole which the reanimated object 'a' of the work of art sought impossibly to fill.

As Lacan memorably said, the essential merit of the work of art was to reach back in fantasy to tickle the Thing from within. Whereas for Freud artistic sublimation entailed the socially acceptable objectification of an unacceptable private wish, Lacan

depreciated the objective work as nothing more than the merest shred of material hanging on a wall that nevertheless managed to grip the viewer with the emancipatory promise of a forbidden and impossible jouissance.

The statue and the Ego

In his pronouncements on the work of art Lacan was always concerned to rip away its deceptive Imaginary moorings in everyday visual experience and establish it in the dignity of a Symbolic discourse with the power to create a new order of satisfaction from the manipulation of the signifier itself. Most of Lacan's remarks on art touched on the medium of painting, but in *Book XVI* of *The Seminar* he initiated an extended commentary on the seventeenth-century sculpture of Roman Catholicism at the time of its resurgence in the war for the soul of Christendom against the austere repudiation of sacred images of the Protestant Reformation. Lacan analysed at length the Imaginary spell of religious statuary, much like Freud, who in 1914 had published an essay on Michelangelo's sculpture of Moses (1515, San Pietro in Vincoli, Rome) in which the liberator of his people was said to be mastering his wrath at the idolatrous dancing of the Israelites around the Golden Calf and restraining himself from smashing the twin tablets of the Law. Imagining himself in the place of his forebears in the Egyptian desert, Freud confessed how his eye trembled beneath the force of the patriarch's terrible gaze.

In a lecture published in the *International Journal of Psycho-Analysis* in 1953 entitled 'Some reflections on the ego', Lacan spoke of the impressive stature of statues as setting the style according to which the bodily Ego erected itself as an Imaginary armoured entity capable of withstanding the withering gaze of the public sphere. At the time this was seen as an alienating effect of the Ego's illusory consolidation upon the mirror stage. Not quite two decades later, however, Lacan stressed the insufficiency of the bodily Ego insofar as the stony permanence of the statue pointed

to something missing in the subject's living flesh, the lost object 'a' of a deathless jouissance. In his zeal to deny not only his own Symbolic castration but also the incompleteness of the idealised Other whose faithful servant he wished to be, the pervert was seen by Lacan as stopping up the unavowable hole in his carnal being with the fetishistic device of the statue. Like the glamorous image of the Hollywood movie star that was a focus of the first generation of Lacanian film criticism in the 1970s, the exhibitionism of the martyred saint or swooning Madonna incited in the viewer the perverse pleasures of voyeurism in which the uncastrated phallus might be seen to remain on unending display. The fleshless stone of the sculpture projected an enduring, undead gaze in front of which the spectator surrendered his or her mortal being to the immortal Thing.

The culmination of Lacan's ruminations on the art of sculpture came in *Book XX* of *The Seminar* under the title *Encore*. Meaning 'More!' or 'Again!', in Lacan's spoken French *encore* also sounded like *en-corps*, 'in the body', the deteriorating body of his later years. Published in French in 1975, *Book XX* was actually the second of the oral seminars to be committed to written form, but it took more than twenty years for it to appear in a complete English edition even though excerpts on feminine sexuality had appeared in a volume edited by Juliet Mitchell and Jacqueline Rose as early as 1982. Against Lacan's earlier articulation of 'The signification of the phallus', the title of the widely read 1958 essay that appeared in the 1977 selected translation of *Ecrits*, in *Encore* he supplemented his notion of the meaning-making jouissance of the Symbolic phallus with an elaboration of what he called the other jouissance of the woman about which nothing precise could be said. With regard to this apparently meaningless yet vital jouissance the example of Roman baroque sculpture played a key, and even notorious, role.

Appearing as the cover illustration of the published seminar, this was the famous sculptural staging of the ecstasy of the

mystical Spanish saint Teresa of Avila, who surrenders herself to a smiling Cupid-like angel wielding the pointed arrow of divine love. In her spiritual autobiography the saint described the paradox of a piercing bodily pain which, in its surpassing sweetness, she did not want to stop. This was the very definition of Lacanian jouissance, a transgressive sexuality already remarked upon in early responses to the sculptural work. Theatrically orchestrated for the burial chapel of Cardinal Federico Cornaro in the church of Santa Maria della Vittoria in Rome by the Italian sculptor and architect Gian Lorenzo Bernini, the bent-back body of the saint in her billowing robes was borne up upon a marble cloud high above the altar (1647–52; Figure 10). The ecstatic ravishment of the saint was raised into this position of Imaginary visibility for the principal benefit of Cardinal Cornaro and his deceased relatives, some of whom were represented on the nearby side walls ratifying the Symbolic significance of the scene in the sidelong gazes they cast upon the work. This confirms Lacan's view that the destiny of the work of art is not to be seen by the artist himself or even by some random other who might be his social peer. Rather, the work of art is fashioned to be shown to the inscrutable gaze of the Other, as represented here by the blank marble busts of the cardinal and his ancestors. In contrast to the oblique disclosure of the skull anamorphically embedded within Holbein's *Ambassadors*, the very acute viewpoint of the Cornaro family would have transformed the meaningful frontal view of the altarpiece into a shapeless marble mass. In this Real disruption of the Imaginary illusion, Bernini caused the essential meaninglessness of the signifier – the material representative of representation – to appear. Furthermore, when we turn our eyes away from the reassuring illusion of the frontal plane and cast down our gaze to our feet we find inscribed upon the floor of the chapel a skeletal spectre of death.

As in the case of Velázquez's theatrical tableau of dynastic love at the Hapsburg court, Bernini has included the courtly viewer

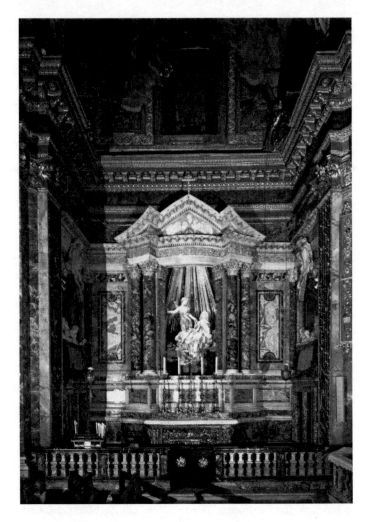

10. Gian Lorenzo
Bernini, *The Ecstacy
of Saint Teresa*
(1647–52).

of the representation of divine love within the space of the representation itself. We latterday spectators stand outside the privileged precinct of the cardinals, who bear witness to the saint's ecstasy from within the sacred confines of the illusionistic space, but we are not entirely excluded from the work of art. Just as in *Las Meninas*, where the perspective expands outward to incorporate us in a window-like frame, here again we occupy a position as the posthumous object of the work's gaze in a virtual window of our own beyond the chapel's rails.

Feminine jouissance

The discussion of Bernini's *Ecstacy of Saint Teresa* flared up in *Encore* in the aftermath of the Roman orgy of museums and churches from which Lacan had recently returned. As always, the reference to the work of art exemplified in visual form an element of psychoanalytic theory that Lacan was trying to articulate in words. Here he was attempting to provide reasonable grounds for his seemingly outlandish claim that there could be no harmonious sexual relationship between women and men because of the asymmetrical positions they occupied with regard to the Symbolic phallic signifier. Whereas all men were said to be subjected to the function of castration such that their lives were played out as a fraudulent farce of appearing to have or not to have Symbolic title to the paternal phallus, there was one man considered to be exempt from this universal rule. This was the uncastrated father of unlimited jouissance who, according to Freud's myth of the primal horde, had possessed all the women of the clan prior to his murder at the hands of his frustrated sons. In contrast to this masculine logic of the universal law and its singular exception, there was no woman, according to Lacan, who was not subject to the function of castration. In compensation for this Symbolic lack, women were made to don the masquerade of femininity and thus become the Imaginary phallic object and cause of masculine desire.

Insofar as a visual fantasy of woman embodied the lost object of masculine desire she was aligned with object 'a' in the Lacanian calculus, but in his view this was not all she was for herself. Although women as speaking beings were said to be subject to Symbolic castration without exception, because a woman was not defined by the masculine quandary of having or not having the phallus, Lacan argued that not all of her was subordinated to the phallic function. Lacan related the feminine quality of not being entirely subjected to Symbolic castration to the lack of a signifier in the phallic vocabulary of the Other for the lost corporeality of jouissance. On the upper tier of the Graph of Desire this strange lack of loss in the jouissance of the woman was indicated by the formula $S(\cancel{A})$, the Signifier of the Other's lack.

Lacanian man had become the bearer of the Symbolic mark or link of signification. The Symbolic phallus was understood as being either present or absent on the basis of the Imaginary model of the erect or flaccid penis of sexual copulation. In contrast, Lacanian woman was described as the signifier that signified no one thing in itself – Woman with a capital letter – but instead inaugurated a space in the Real without which no particular signifier could come to take on any Symbolic meaning at all. The jouissance of the castrated man was subject to the rigid phallic code of either/or, but woman was neither castrated nor uncastrated. Hers was a supplementary jouissance beyond the phallus adrift in the flow of an endless signification, a Real jouissance of the body, *en-corps*, of which nothing final but always something more, *encore*, could be said. As for Bernini's Saint Teresa, she was coming, Lacan avowed, twisting into a positive light earlier condemnations of the saint's orgasmic corporeality. Whereas Saint Teresa was alleged to know nothing of the nature of her jouissance, Lacan provocatively claimed that psychoanalysis did. In this way Lacan repeated the implication of Freud's infamous question, 'What does Woman want?', *Was will das Weib?*, that the woman herself does not know what she wants. But

perhaps Saint Teresa did know something whereof she spoke, for in writing of her ecstacy she insisted that the pain she enjoyed was not of the body, but of the spirit, even if the body had its share in it. That was the jouissance of writing itself.

Many feminists have taken harsh exception to the Lacanian scenario of the all-or-nothing of masculinity and the not-all of femininity, just as other feminists have saluted Lacan for his emancipatory displacement of the totalitarian reign of the phallic signifier. The point that I want to stress is that, according to Lacan in *Encore*, women and men alike are able to situate themselves on one side or the other of the Symbolic divide of sex irrespective of the biological attributes of their bodies, as seen in the transgendered performances of Jaye Davidson in *The Crying Game* (1992) or Hilary Swank in *Boys Don't Cry* (1999), to take just two notable examples from recent films.

Lacan insisted that history was full of phallic women and non-phallic men, mystics such as Saint John of the Cross, or indeed Lacan himself in the mystical jaculations, as he called them, of his *Ecrits*. In front of his mystified seminar Lacan repeatedly – hysterically – exhibited himself in the position of the non-phallic jouissance of the not-whole woman. Identifying his lack with the other jouissance of the woman, Lacan's transgressive enjoyment was not in the masturbatory orgasm of the bachelors in the lower section of *The Large Glass* but, rather, in his paroxysms of speech in the manner of Bernini's saint and Duchamp's similarly airborne female apparition in the upper register of *The Bride Stripped Bare*. As an historical function of the address of feminine jouissance to the ear of the divine Other, the Other's unseen face took on the all-seeing invisibility of the gaze of God. For Lacan, the name of that gaze was simply love, the non-sexual regard of the analyst for the essential suffering of the patient. Similarly, for Duchamp, the ecstatic suffering of his quasi-mechanical bride was fuelled by the gasoline of love (*essence d'amour*).

There is no sexual relation

The aim of Lacan's teaching on the non-reciprocity of the sexual relation was to distinguish the so-called masculine enjoyment of the fantasised lost object embedded in the partner's maternalised body from the so-called feminine jouissance of the partner's mutilated body insofar as he or she bore the mark of being castrated, not-whole, and therefore in vital need of the selfless gift of love. One form of the acknowledgement of the lack in the other was the ambiguous smile we encountered on the face of Saint Anne at the start of this book. Here, near the end of the book, we encounter another such smile on the face of the angel who sutured together the severed unity of the Real body and Imaginary soul of Saint Teresa with the Symbolic arrow of love. Like the androgynous smiling angels of Leonardo, who, for Freud, harboured the indescribable secret of bliss, Bernini's angel also became the wordless instrument of feminine jouissance. It was not Saint Teresa's fantasised possession of the lost maternal phallus, breast, gaze or voice that could be successfully targeted by the thrusting arrow of phallic jouissance. Rather, in her wound Lacan saw the inadequacy of any Imaginary visualisation of the saint's transverberation. No single Symbolic signifier could fill that Real gap of inexpressibility, but perhaps the boundless *encore* of love could.

One of the key blackboard diagrams reproduced in the pages of *Encore* is an equilateral triangle representing the interaction of the Imaginary, Symbolic and Real dimensions of gendered and sexed human experience. On the sides of the triangle between the Imaginary and the Real lies the meagre reality of the corporeal penis, designated by Φ the capital letter phi. Between the Imaginary and the Symbolic lies the truth of the lacking signifier of feminine jouissance, designated by $S(\not{A})$. And between the Symbolic and the Real lies the semblance of lost vitality that is the object 'a'. Using Lacan's triangular template, I can map out the distribution of elements in Bernini's work in the following way.

The Imaginary schema of the sculptural tableau is visually unified by a compositional link between the concrete reality of the angel's arrow of phallic jouissance and the ineffably represented truth of the saint's other jouissance of enraptured silence. The Symbolic scenario of the work is suspended between the sacred narrative of the saint's endlessly deferred coming and the profane semblance of the lost phallic object that would miraculously accomplish the deed. But the earthbound Real of the sculptor's chiselled stones resist their cloud-borne visualisation and symbolisation, for there is an almost comic disjunction in the bronze arrow between its obtuseness as a material prop for the lost object 'a'nd the inadequacy of any actual biological organ to maintain a woman in such a state of everlasting erotic bliss. In Lacan's diagram the rigid sides of the triangle constrain a perilous pool of jouissance from overflowing its boundaries while maintaining it as a precious fluid reserve. The uncanny liquefaction of Bernini's frozen marble is the sublimated sign of a surreal jouissance that spares the subject from the compulsions and frustrations of any actually attempted sexual enjoyment. Lacan called this artistic exposure of the faulty infrastructure of the human sexual relation an X-ray of the soul.

What Bernini's flamboyant style was to the high period of the Roman baroque Lacan's verbal pyrotechnics was to the later decades of Parisian surrealism, even if he sometimes disavowed his early connections to the movement. Whereas his ornate and ornery play on words was often thrown in his face in the disdainful criticism of his self-styled scientific peers, Lacan openly embraced baroque excess as his personal emblem in *Encore*. His alliterative and assonant manipulation of language constituted a formal fashioning of the verbal signifier that mimed the overtly theatrical display of the baroque style. Lacan's verbal style also enacted something of the tortuous rhythms of the signifier as enunciated in the analysand's dreams, slips of the tongue and free associations. Lacan was especially keen on pushing his public speech, like

Bernini's soft stone, to a point of communicative excess where the artistic sublimation of the failure of the sexual relationship might be felt to release a compensatory visceral remnant of unrepressed, wholly unreasonable jouissance. Lacan's weekly oral seminar was not fucking, he once said, but it was his object 'a', the sensual materiality of speech that reconnected him to the primal void of his lost mother-child flesh.

Identifying himself with the delirious ecstacy of the female saint in the seminar of 1972–3, the seventy-year-old Lacan found himself again, *encore*, in the grip of the visual delusions of the female patient upon whose case of paranoid criminal assault his doctoral dissertation of 1932 had been based. Named Aimée ('Beloved', in English), hers was a notorious case of transgressive jouissance that greatly stirred the masculine circles of surrealism and provided the link that first drew together Lacan and Dalí. Just as the painter had claimed of his paranoiac-critical method that the only difference between his visions and those of the insane was that he was not mad, so Lacan claimed in *Encore* that the difference between himself and the mystical women who displayed the non-phallic jouissance of the Other was that he knew a bit about it but they did not. Besides Dalí's 1954 photographic impersonation of the *Mona Lisa* that I have already noted, an earlier artistic precedent for Lacan's gender-bending identifications were Man Ray's famous photographs of Duchamp in the guise of his feminine alter Ego, Rrose Sélavy (1920–1, Philadelphia Museum of Art). Pronouncing the Real double 'R' of the name in French, we discover in this Imaginary blending of woman and man the Symbolic dictum that 'Eros, c'est la vie', 'Eros is life'.

From Lacan's perspective of the speaking being facing up to the Real void of the object 'a', the visual and verbal excesses of Christian art and mysticism sublimated the impasse of sexual relations in the form of sacred ecstacy and martyrdom. That was what the kilometres of renaissance and baroque paintings in our museums and churches bore witness to, until the slate was wiped

clean by the modernist preoccupation with the geometric relations of the little squares, say, of Kasimir Malevich and Piet Mondrian, whose austere axial crossings derive, respectively, from Russian Orthodox icons and the architecture of Dutch Reformed churches. Lacan's post-Christian and modernist preoccupation with mathematical topology and the theory of knots was nothing less. One of Lacan's final written texts was the introduction to an exhibition in 1978 of abstract paintings of intricately knotted and woven strands and bands of colour by the French painter François Rouan. Rouan in turn saluted Lacan's formula for the work of art as the formal encircling of the void at the human being's heart. His elegant stained-glass windows for the cathedral of Nevers in central France (1991) return the triadic interlace of the Real, the Imaginary and the Symbolic to its roots in the Christian theology of the trinity and the elaborate geometrical tracery of Gothic windows.

Lacan's seminars after *Encore* repeated many of the themes that had preoccupied him for years. On the one hand, in the rhetorical provocations of his speech, Lacan repeatedly put himself in the place of the hysterical patients of Freud whose unconstrained talk of their bodily symptoms challenged the social convention of proper feminine behaviour and led to the invention of the talking cure, a term offered to Freud by one of those turn-of-the-century women. On the other hand, in the nearly compulsive repetition of his quasi-mathematical formulas and diagrams, Lacan positioned himself in the typically masculine role of Freud's obsessional patients who sought to establish the uncastrated wholeness of the father through their ritualised adherence to the letter of an obscure law.

The symptom

Freud had claimed a common obsessional structure for art and religion, but Lacan apologised to the artists in his audience in this respect. In his later years Lacan insisted on the affinity between the working procedures of the artist and the analyst in laying

bare the objective framework of the subject's carnal symptom. The emancipatory promise in art and analysis was no longer to eliminate the symptom through Symbolic interpretation by reducing it to the physical effect of a repressed childhood memory, as Freud in his treatise on Leonardo appeared to believe. Rather, the goal in art and analysis was to scrutinise the symptom from all sides, to take responsibility for the unique formal organisation of one's most intimate jouissance, to recognise the unbreakable link between one's ineffable subjectivity and the senseless objectivity of the symptom, to identify with this link, and then to let it be. Already at the end of his 'Mirror stage' essay Lacan had borrowed the sacred Hindu formula, 'Thou art that!', in order to register something of the paradoxical conjunction between the subject's disembodied Symbolic consciousness and the abject traces of its own vanished embodiment in the Real.

The unpublished seminar twenty-one, in which Lacan remade these points, was named for the fundamental uncertainty of the paternal foundation of the Symbolic order. *Les Non-dupes errent* was a phonetic retranscription of *Les Noms du père*, the name of the abortive seminar of 1963 on the Names of the Father. Sounding the same, this inventive punning on the father's names took on the new meaning of the error of those who did not let themselves be duped. The error of the subject was to remain trapped in the perceptual immediacy of the Imaginary relation to the mother rather than to allow itself to be productively duped by the Symbolic fiction of the father's name. And it was in the Symbolic freedom of the movement of the brush upon the Real warp and weft of the canvas that something new in painting might be born. With the pointed application of a painted mark the painter might parry the Imaginary gaze of the Thing that would pull him or her back from the brink of public achievement into its regressive embrace.

Faced by the daunting void of the blackboard upon which he hoped to transmit the formulas and diagrams of his psychoanalytic legacy, Lacan was like Velázquez, recoiling from the blankness of

the unseen canvas that taunted him in *Las Meninas*. Ten years after his lectures on the painting Lacan repeated his identification with the enigmatic gaze of the seventeenth-century artist in the unpublished seminar twenty-two entitled *R. S. I.* A catchy acronym for the psychoanalytic triad of the Real, the Symbolic and the Imaginary, when pronounced in French *R. S. I.* sounded like *hérésie*, heresy. Stubbornly sustaining his subversive superimposition of the secular trinity of psychoanalysis upon the religious trinity of the Father, the Son and the Holy Ghost, Lacan was a haunted heretic who could never wholly renounce the scripture in which he had been raised and to which his brother Marc-Marie devoted his life as a monk. The surging forth of jouissance was not the cause but, rather, the effect of the Symbolic act of creation that took its primary model from the Gospel of John, in which it was written that in the beginning of the World was the Word.

The Word in its World-making power was the shared medium of scriptural, analytic and artistic creation. In *Book XXIII* of *The Seminar*, from 1975–6, Lacan returned to the formative years of Parisian surrealism, when he had first encountered the religious and artistic transgressions of James Joyce, the avant-garde Irish Catholic author of *Ulysses* (1922). In the seminar he conducted fifty years after witnessing Joyce read from his landmark text in an avant-garde Parisian bookstore, Lacan proposed an archaic spelling for the symptom – *sinthome* – that was itself a thoroughly Joycean bilingual pun. In distinguishing the Imaginary perceptual sound of *symptôme* from its imperceptual Symbolic spelling of *sinthome*, Lacan invited his initial listeners and subsequent readers to hear and see a profusion of signifiers variously related to the theme of sin. In the letters of *sinthome* we find the indelible stain inscribed upon the tome of the book and the tomb of the body. This tome/tomb is the memorial home of homme or man. As pronounced in French, *sin* sounds like *saint*, specifically Saint Thomas, the doubter of the resurrection of

Christ, and Saint Thomas Aquinas, the author of the doctrine of the resurrection of the body that Lacan himself no longer shared. In the diagram-strewn pages of this seminar Lacan worked out in obsessive detail how the disparate orders of Joyce's personal history, hysteria and heresy were precariously knotted together to provide the author with a crucial consistency of being in the form of the *sinthome*-symptom of the literary work of art. In *Totem and Taboo* of 1913 Freud had called the physical symptom of the hysteric a corporeal caricature of the physical materiality of a work of art, a definition that was silently endorsed sixty years later in Lacan's seminar on Joyce.

Borromean rings

For several years Lacan had been knotting rings of string and drawing blackboard pictures of these rings in an effort to construct a topology of the human subject in which the intertwining of the Real, Symbolic and Imaginary dimensions of being could be grasped directly. A variation on a medieval emblem in which the unity of the trinity was represented as the interlacing of three rings, the version of the knot that caught Lacan's fancy was named Borromean, after the coat of arms of a Milanese clan of the fifteenth century whose power depended on the joint alliance of three noble families. In spite of this visual affirmation of unity, we should remember that the word for knot in French, *noeud*, is a nearly indistinguishable sound-twin of *ne*, the sign of negation, just as in English the word *knot* is the strict homophone of *not*. The purely Symbolic silence of the letter 'k' is all that is needed to make something of nothing, as we know.

To make a Borromean knot of three rings – Lacan distinguished them on the board with blue, white and red chalk, the French tricolour – each ring must be passed over and under its mates in such a manner that the resulting three-in-one unity will come undone with the severing of any one of the rings. Whereas Freud awarded finger rings to the inner circle of his disciples, Lacan

appeared to aspire to the title of Lord of the Borromean Rings, a version of which is illustrated below.

Let the ring at the top represent the Imaginary, the ring at the right the Symbolic and the ring at the left the Real. Moving our eyes in a clockwise direction, we see that the right-hand edge of the ring of the Imaginary goes over the ring of the Symbolic beneath it, under the right-hand edge of the ring of the Real above it, over the left-hand edge of the Symbolic beneath it, and under the left-hand edge of the Real above it. In the intersection at the right between the Imaginary and Symbolic rings, Lacan placed the illusory effect of freezing the multiple potentiality of the signifier into a unitary signified meaning. In the intersection at the bottom of the Symbolic and Real rings, he situated the space where the pathetic reality of the penis met the limited experience of jouissance permitted by the paternal regime of Symbolic castration. In the intersection at the left of the Real and Imaginary rings, he located the jouissance of the Other of which nothing definitive could be said due to the lack of an adequate signifier. This was also the place of an heretical hole in being, for on Lacan's

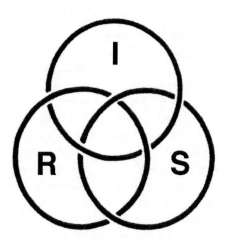

atheistic account there existed no Other of the Other, no One to guarantee the knowledge of what it would take to recover paradise lost. Therefore, in the central void where the three orders were superimposed, Lacan inscribed the suturing effect of the object 'a', the endlessly circular pursuit of which maintained a minimal semblance of being for the divided subject of language and jouissance.

Failure on the part of the Symbolic paternal metaphor to sustain its interlocking position with regard to the Imaginary demands of maternal desire and the Real needs of corporeal jouissance would result in the unravelling of the perceptual-physical-psychic knot and the psychotic disintegration of the subject's world. As in the cases of Leonardo and Little Hans, this failure was what Lacan discerned in the inadequacy of the father of Joyce, but it was Joyce's singular joy to author in the signifiers of his art an originality and consistency of style that prevented the triple knot of his world from coming apart. Constituting a precious fourth ring forging a single chain from the disparate links of the Real, the Symbolic and the Imaginary, the unique style of the artist was now seen by Lacan in a new light. Not only was the creation of the work an act of sublimation whereby the subject of unconscious desire was safely able to stage a visual fantasy of the lost Thing, the creation of the work of art was also the direct production of a dazzling object of jouissance for the symptomatic subject of the irrepressible drive.

Art was a practical form of knowledge, a *savoir-faire* of jouissance, as Lacan affirmed in his unpublished twenty-fourth seminar on the punning wit of unconscious knowledge. In the strictly untranslatable title of the seminar – *L'Insu que sait de l'une bévue s'aile à mourre* – Lacan fused the formalist 'wordjoy' of Dublin, Vienna and Paris in an intoxicating cocktail of sounds and meanings in which the unsuccess – *l'insuccès* – or lunatic blundering – *lune bévue* – of the subject of the unconscious – in German, *das Unbewusste* – was a game of chance – *mourre* – in

which one sailed off to mortal love and death – *amour/mort*. And the transgendered pun on the initial letter *L* – *elle*, she – of Lacan's name was perhaps to be heard in the word for wing – *aile* – as well.

As for art, Lacan opined in the seminar that the abstract painter, like the idealist philosopher, was a metaphysician insofar as his or her crude Imaginary schemas were torn away from any erroneous notion of a direct correspondence with reality by the simple Symbolic expedient of providing an arbitrary verbal title for the visual work. Corresponding to the endless elaboration of the Symbolic titles of paintings, even when the title of a work was *Untitled*, truth was to be discovered in art not in some Imaginary verity of visual reflection, but in the Real variety of pictorial matter in which was made manifest the artist's own symptomatic organisation of jouissance. As the psychoanalyst punctuated the flow of signifiers of the analysand's discourse in order to bring out the invisible structure of its underlying formal relations, so too the critic or historian cut into the seamlessness of the image with a singular articulation of signifiers, a novel interpretation of the work that rendered it partial, poetic or partisan, and therefore not-whole.

Now it was the moment to conclude, this being the title of Lacan's unpublished twenty-fifth seminar, in which the aging analyst continued to practice his endless art, like Ulysses' wife Penelope at her loom, of weaving and unweaving the tricoloured strands of Real life, Imaginary love and Symbolic death. In the unpublished twenty-sixth seminar the tragicomic Lacanian drama was entitled *Topology and Time*, an impossible twining of the disparate strands of subjective existence that can neither recapture the first object lost nor forestall the final objectification to come. Nonetheless, for all his fantasy, fallacy and failure, Lacan faltered on to the end.

Afterword: *Enjoy!*

Like the analysand who comes to recognise him- or herself in the analyst in whose blank unresponsive gaze the loss of the object 'a' is made manifest, so too the artist sustains him- or herself within the empty frame of the work to be accomplished in relation to the loss that first gave rise to desire. Looking at the painting in the making, the artist asks: 'Is that it? Is that what I desire? Perhaps this time this will be it; Please, let this be it... No, no. That's not it, damn it! I guess there's nothing to do but to try to re-imagine it all over again, *encore*!'

The Imaginary dimension of the work's reflective surface can be both nourishing and withholding, like the formative experience of the child at the mother's breast. Therein lies the ambivalence of the fantasy of the other who is thought to possess the precious object 'a', like the nursling brother of Saint Augustine discussed in *Book XI* of *The Seminar*, *The Four Fundamental Concepts of Psychoanalysis*, and again in *Book XX, Encore*. There Lacan recounted the encounter of the eye/I of the subject (*video*, in Latin) with the gaze of the other that provoked in Augustine a radical envy (*invidia*) of his brother's apparent enjoyment of the desired object. This was an object, however, that the weaned subject would have had no joy in possessing for itself. Augustine's nursling brother of envied enjoyment was also a textual brother of the Christ Child in the lap of the Madonna in the version by Leonardo that Lacan discussed in *Book IV* of *The Seminar*, *The Object Relation*, and again in the version in the Brera Museum in Milan by Bramantino (1520). The latter was discussed in the last public seminar Lacan

gave in 1980, in Caracas, Venezuela. This unpublished seminar was given a fitting title of finality and futility, *Dissolution*.

Facing Bramantino's painting with the trademark delirium of his surrealist response to pictures, the eighty-year-old Lacan noted the phantom appearance of a Christ-like beard on the face of the Madonna, whose Thingly embrace of the child in the vast volume of her draperies threatened to reabsorb into her body the lost object 'a' that was her baby. His tiny penis, barely denoted by the artist, is the Symbolic sign of the Real impossibility on the side of both mother and child to consummate the dual incestuous fantasy of being or having the Imaginary phallus of maternal desire. Like the analyst looking at and listening to the analysand from behind and to the side, the father Joseph stands impassively at the side of the nursing couple holding a phallic staff at the level of his loins, his profiled body sharply severed by the painting's left-hand framing edge. Noting a frog in the foreground of the painting, Lacan translated the painting into a freely created Symbolic text in which his decades-long fear of maternal engulfment was expressed. The painting, he said to his Spanish-speaking audience, bore witness to the fact that a woman was not a frog, *grenouille* being, in French, a vulgar appellation for prostitute. In Symbolically linking virgin and whore in the visual and verbal signifier of 'frog', Lacan was again insisting on the sublimating capacity of his speech to fuse in a formal structure of fantasy our highest rhetorical ideals and basest corporeal impulses. In this respect Lacan felt that he had learned more successfully than Freud how to differentiate the double discourse of desire and drive – $<>@. Lacan followed Freud in relating the Imaginary and Symbolic elements of art to the unconscious substitutive mechanisms of condensation and displacement, but he also insisted on the unsublimated shreds of Real enjoyment sustained in the artistic encircling of the object 'a'.

On the brink of death Lacan was deeply anxious about his legitimacy as heir to the legacy of Freud. In the confession in this

final seminar of his initial difficulty in recalling the name of the painter Bramantino, Lacan identified himself with one of Freud's founding psychoanalytic gestures in *The Psychopathology of Everyday Life* (1901). As recounted in the first book of his *Seminar*, as well as on many subsequent occasions, Lacan admired Freud's reconstruction of the blockages and displacements of verbal signifiers that stood behind his failure to remember the name of the Italian painter Luca Signorelli while conversing with a stranger on a train travelling through the Muslim enclave of Bosnia in the former Austro-Hungarian empire. Although the *-elli* fragment of Signorelli's name readily reappeared in Freud's uttering the name 'Botticelli', the fragment *Signor* remained repressed. Freud speculated that this repression came about because just then he was being told the disturbing story of a doctor, honorifically referred to as *Herr*, the German equivalent of *signor* or sir, who had to deliver news of a terminal illness to the family of a patient. This caused Freud to muse privately on the high value placed on sex by a Muslim patient of his acquaintance, who had declared to him that death was to be preferred to impotence. It was this knotted tangle of sexuality, religion and death that had kept the name of Signorelli under the seal of repression. Signorelli was the author of a famous fresco in the cathedral at Orvieto (1500) depicting the deeds of the Antichrist, and within it he included a self-portrait whose vivid Imaginary gaze Freud saw in his mind's eye before he managed to retrieve the artist's troublesome Symbolic name.

As self-portraying impresarios of the clashing drives of sexuality and death, Freud, the 'godless Jew' (as he called himself), and Lacan, the heretical Christian atheist, might well have seen themselves in the double role of the artist and the Antichrist. Gazed at by their anxious antagonists inside and outside the practice of their black craft, Freud and Lacan were the cursed viral agents of the plague of psychoanalysis. Suspended above a deep cultural abyss between the domains of science and art, psychoanalysis was indelibly stained by the Real stench of

sexuality and death. And yet, by writing and talking about It along the taut Symbolic tightrope of the signifier, an unholy psychoanalysis might also be wholly without illusion in the acknowledgement of Being's unstoppable hole.

So, in the end, 'Why Lacan?', for us anxious students of the arts. To reframe, artfully, our haunting mirrors of sexuality and death, and to struggle to be free.

Selected bibliography

Ecrits, Paris: Seuil, 1966.

Ecrits: A selection, trans. Alan Sheridan, New York: Norton, 1977.

Ecrits: The first complete edition in English, trans. Bruce Fink, New York: Norton, 2005.

Le Séminaire, Livre I: Les Ecrits techniques de Freud, 1953–54, ed. Jacques-Alain Miller, Paris: Seuil, 1975.

The Seminar, Book I: Freud's papers on technique, 1953–54, trans. John Forrester, New York: Norton, 1988.

Le Séminaire, Livre II: Le Moi dans la théorie de Freud et dans la technique de la psychanalyse, 1954–55, ed. Jacques-Alain Miller, Paris: Seuil, 1978.

The Seminar, Book II: The ego in Freud's theory and in the technique of psychoanalysis, 1954–55, trans. Sylvana Tomaselli, New York: Norton, 1988.

Le Séminaire, Livre III: Les Psychoses, 1955–56, ed. Jacques-Alain Miller, Paris: Seuil, 1981.

The Seminar, Book III: The psychoses, 1955–56, trans. Russell Grigg, New York: Norton, 1993.

Le Séminaire, Livre IV: La Relation d'objet, 1956–57, ed. Jacques-Alain Miller, Paris: Seuil, 1994. Untranslated.

Le Séminaire, Livre V: Les Formations de l'inconscient, 1957–58, ed. Jacques-Alain Miller, Paris: Seuil, 1998. Untranslated.

Le Séminaire, Livre VI: Le Désir et son interprétation, 1958–59. Unpublished.

Le Séminaire, Livre VII: L'Ethique de la psychanalyse, 1959–60, ed. Jacques-Alain Miller, Paris: Seuil, 1986.

The Seminar, Book VII: The ethics of psychoanalysis, 1959–60, trans. Dennis Potter, New York: Norton, 1992.

Le Séminaire, Livre VIII: Le Transfert, 1960–61, ed. Jacques-Alain Miller, Paris: Seuil, 1991. Untranslated.

Le Séminaire, Livre IX: L'Identification, 1961–62. Unpublished.

Le Séminaire, Livre X: L'Angoisse, 1962–63, ed. Jacques-Alain Miller, Paris: Seuil, 2004. Untranslated.

Des Noms-du-Père, 1963, ed. Jacques-Alain Miller, Paris: Seuil, 2005.

'Introduction to the Names-of-the-Father seminar', trans. Jeffrey Mehlman, in *Television: A challenge to the psychoanalytic establishment*, ed. Joan Copjec, New York: Norton, 1990.

Le Séminaire, Livre XI: Les Quatre concepts fondamentaux de la psychanalyse, 1964, ed. Jacques-Alain Miller, Paris: Seuil, 1973.

The Seminar, Book XI: The four fundamental concepts of psychoanalysis, 1964, trans. Alan Sheridan, New York: Norton, 1977.

Le Séminaire, Livre XII: Problèmes cruciaux pour la psychanalyse, 1964–65. Unpublished.

Le Séminaire, Livre XIII: L'Objet de la psychanalyse, 1965–66. Unpublished.

Le Séminaire, Livre XIV: La logique du fantasme, 1966–67. Unpublished.

Le Séminaire, Livre XV: L'acte psychanalytique, 1967–68. Unpublished.

Le Séminaire, Livre XVI: D'un Autre à l'autre, 1968–69, ed. Jacques-Alain Miller, Paris: Seuil, 2006. Untranslated.

Le Séminaire, Livre XVII: L'envers de la psychanalyse, 1969–70, ed. Jacques-Alain Miller, Paris: Seuil, 1991.

The Seminar, Book XVII: The other side of psychoanalysis 1969–70, trans. Russell Grigg, New York: Norton, 2006.

Le Séminaire, Livre XVIII: D'un discours qui ne serait pas du semblant, 1970–71, ed. Jacques-Alain Miller, Paris: Seuil, 2007.

Le séminaire, Livre XIX:...ou pire, 1971–72. Unpublished.

Le Séminaire, Livre XIX bis: Le Savoir du psychanalyste, 1971–72. Unpublished.

Le Séminaire, Livre XX: Encore, 1972–73, ed. Jacques-Alain Miller, Paris: Seuil, 1975.

Feminine Sexuality: Jacques Lacan and the école freudienne, ed. Juliet Mitchell and Jaqueline Rose, trans. Jacqueline Rose, New York: Norton, 1982.

The Seminar, Book XX: On feminine sexuality, the limits of love and knowledge: Encore, 1972–73, trans. Bruce Fink, New York: Norton, 1998.

Le Séminaire, Livre XXI: Les Non-dupes errent, 1973–74. Unpublished.

Le Séminaire, Livre XXII: R.S.I., 1974–75. Unpublished.

Le Séminaire, Livre XXIII: Le Sinthome, 1975–76, ed. Jacques-Alain Miller, Paris: Seuil, 2005. Untranslated.

Le Séminaire, Livre XXIV: L'Insu que sait de l'une bévue s'aile à mourre, 1976–77. Unpublished.

Le Séminaire, Livre XXV: Le Moment de conclure, 1977–78. Unpublished.

Le Séminaire, Livre XXVI: La Topologie et le temps, 1978–79. Unpublished.

Le Séminaire, Livre XXVII: Dissolution, 1980. Unpublished.

French transcriptions of unpublished seminars are available at http://gaogoa.free.fr/SeminaireS.htm.

Suggested reading

The best general introduction to art and psychoanalysis is *Psychoanalytic Criticism: A reappraisal* (Polity Press, 2nd edition, 1998) by the late Elizabeth Wright. Also very useful is her edited volume, *Feminism and Psychoanalysis: A critical dictionary* (Blackwell, 1992), with a helpful entry on art and psychoanalysis by the art historian Griselda Pollock. Pollock's most recent edited volume, with Dana Arnold, is *Psychoanalysis and the Image: Transdisciplinary perspectives* (Blackwell, 2006).

A good introduction to Lacan in comic-book format is Darian Leader, *Introducing Lacan* (Totem Books, 3rd edition, 2006). A Lacanian analyst and critic, Leader has also written an elegant book on art, *Stealing the Mona Lisa: What art stops us from seeing* (Counterpoint Press, 2002). Two challenging sets of essays on Lacan and art written and edited by Parveen Adams are *The Emptiness of the Image* (Routledge, 1995) and *Art: Sublimation or symptom* (Other Press, 2003). The journal *Lacanian Ink* (Wooster Press) publishes occasional articles on art by leading international Lacanian writers. Its website (www.lacan.com) is a treasure trove of Lacanian links. The French psychoanalyst Jean-Louis Sous has created a studious and playful CD-ROM, *Lacan et la peinture* (Editions Chrysis, 2005), that conveniently provides illustrations and excerpts of many of the most important passages on the art of painting by Lacan.

Bruce Fink, translator of the complete edition of *Écrits* (Norton, 2005), is the author and editor of many important books on Lacan, including the excellent *The Lacanian Subject: Between language*

and jouissance (Princeton University Press, 1996). I also recommend the systematic presentation of the Lacanian triad of the Imaginary, the Symbolic and the Real in Robert Samuels, *Between Philosophy and Psychoanalysis* (Routledge, 1993). Also interesting is his application of Lacan to the reading of film, *Hitchcock's Bi-textuality: Lacan, feminisms, and queer theory* (State University of New York Press, 1998).

An indispensable work of reference is by the former Lacanian analyst Dylan Evans, *An Introductory Dictionary of Lacanian Psychoanalysis* (Routledge, 1996), now conveniently available at the constantly updated website No Subject: Encyclopedia of Psychoanalysis (www.nosubject.com). Also to be consulted in a convenient dictionary format is *A Compendium of Lacanian Terms* (Free Association Books, 2001), edited by Huguette Glowinski, Zita Marks and Sara Murphy.

The writer and editor most responsible for placing Lacan at the forefront of contemporary cultural and political analysis, and the inspiration for much of my own engagement with Lacan, is the Slovenian leftist philosopher Slavoj Žižek, whose hilarious, provocative, and most pertinent works for students of art and visual media are *Looking Awry: An introduction to Jacques Lacan through popular culture* (MIT Press, 1992), *Everything You Always Wanted to Know about Lacan (But Were Afraid to Ask Hitchcock)* (Verso, 1992), *Enjoy Your Symptom! Jacques Lacan in Hollywood and Out* (Routledge, 2nd edition, 2001), and, for modernist painting, *The Fragile Absolute or, Why is the Christian Legacy Worth Fighting For?* (Verso, 2000). Žižek has recently published an introduction to Lacan that cannibalises many of his previous books in a very palatable form, *How to Read Lacan* (Granta, 2006). Also not to be missed is his Lacanian introduction to the history and theory of film in DVD format, *The Pervert's Guide to Cinema* (2006). And for a discussion of literature and the visual arts that seeks to separate the idealism of Žižek from the materialism of Lacan, see Catherine Belsey, *Culture and the Real* (Routledge, 2004).

Finally, some essays of mine on art and Lacan are 'Virtual Narcissus: On the mirror stage with Monet, Lacan, and me', *American Imago* 53 (Spring 1996), 91–106; 'Manet's Man Meets the Gleam of Her Gaze: A psychoanalytic novel', in *12 Views of Manet's 'Bar'*, ed. Bradford R. Collins (Princeton University Press, 1996), 250–77; 'Between Art History and Psychoanalysis: I/Eye-ing Monet with Freud and Lacan', in *The Subjects of Art History: Historical Objects in Contemporary Perspective*, ed. Mark A. Cheetham, Michael Ann Holly and Keith Moxey (Cambridge University Press, 1998), 197–212; 'October's Lacan, or In the Beginning Was the Void', in *Lacan in America*, ed. Jean-Michel Rabaté (Other Press, 2000), 139–52. Enjoy!

Index